Charlene M. Miller

Charlene M. Miller

# INTUITIVE
# COMPOSITION

# INTUITIVE COMPOSITION

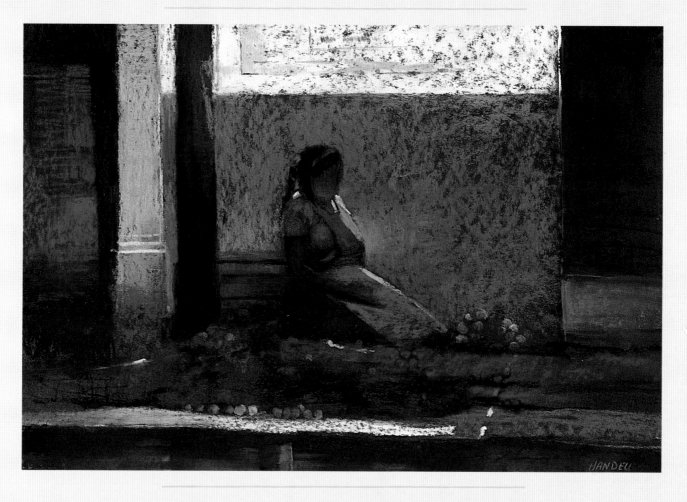

ALBERT HANDELL AND LESLIE TRAINOR HANDELL

*Watson-Guptill Publications / New York*

## Painting Information

Title page:
CONTEMPLATION—1988, *pastel, 10½" x 15½" (26.6 x 39.3 cm). Courtesy of the Ventana Gallery, Santa Fe, New Mexico.*

Page 5:
TESUQUE LIGHT, *oil on masonite panel, 28" x 28" (71.1 x 71.1 cm). Private collection.*

Page 8:
AFTER THE RAIN, *pastel on sanded board, 18" x 24" (45.7 x 60.9 cm). Collection of Thomas and Mary James. Located in Raymond James Financial Center.*

Pages 10–11:
SANTA FE HILLS, *pastel, 15¾" x 21½" (40.0 x 54.6 cm). Courtesy of the Ventana Gallery, Santa Fe, New Mexico.*

Pages 24–25:
COTTON WOOD GROVE, *pastel, 11" x 15¾" (27.9 x 40.0 cm). Courtesy of the Ventana Gallery, Santa Fe, New Mexico.*

Pages 62–63:
THE DELIVERY, *pastel, 11" x 15½" (27.9 x 39.3 cm). Courtesy of the Ventana Gallery, Santa Fe, New Mexico.*

Pages 96–97:
SHADOWS, SANTA FE, *pastel, 16" x 22" (40.6 x 55.8 cm). Collection of Lori Liken.*

Copyright © 1989 by Albert Handell and Leslie Trainor Handell
First published in 1989 by Watson-Guptill Publications,
a division of Billboard Publications,
1515 Broadway, New York, N.Y. 10036

**Library of Congress Cataloging in Publication Data**
Handell, Albert, 1937–
Intuitive composition / by Albert Handell and Leslie Trainor Handell.
    p.  cm.
    Includes index.
    1. Painting—Technique.  2. Composition (Art)  3. Visual perception.
4.  Cerebral dominance.  5. Laterality.  I. Handell, Leslie Trainor.
II. Title.
ND1475.H35    1989     89–9026
751.4–dc20          CIP
ISBN 0–8230–2545–4

Distributed in the United Kingdom by Phaidon Press Ltd.,
Musterlin House, Jordan Hill Road, Oxford OX2  8DP

Manufactured in Singapore

2  3  4  5  6  7  8  9  10  /  93  92  91

*To Micah*

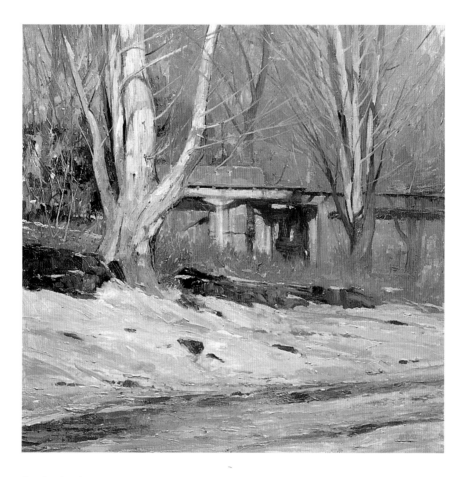

I'm thankful to my students for their interest in my works and my teaching, and for their questions, which through the years have forced me to articulate my thoughts and feelings.

And I want to thank my wife, Leslie, my coauthor, for all the work she put into organizing, writing, and editing this book. *Intuitive Composition* was her idea, predicated on her understanding and love for me and her understanding of books. This is our third book together, and by far the most fun. I am thankful for her help and love.

# Contents

Introduction   9

*Part One*
SEEING COMPOSITION   10
Seeing   12
Perception and Personal Vision   14
Reality and Artistic Vision   16
Simplicity, Harmony, and Balance   17
Realism and Abstraction: The Appearance of Reality   20
Intuition and Feeling   22

*Part Two*
ELEMENTS OF COMPOSITION   24
Shapes   26
Patterns   30
Planes   32
Positive and Negative Shapes   34
Empty Negative Space   37
Types of Movement   39

*Part Three*
TECHNICAL INFLUENCES ON COMPOSITION   62
Values and Masses in Composition   64
Light and Shade   66
Color in Composition   70
Lost and Found Edges   76
Detail and the Art of Selective Finishing   78
Texture   80

Luminosity, Weight, and Atmosphere   *82*

Tension   *88*

Proportional Relationships   *90*

Linear and Aerial Perspective   *92*

Lines and Subjective Lines   *94*

*Part Four*
CREATIVE APPROACHES   *96*

The First Impression   *98*

Center of Interest in Composition   *100*

Artistic License   *102*

Composing from Life   *104*

Composing from Drawings   *106*

Composing from Photographs   *110*

Placement   *114*

Simplifying Shapes and Unifying Compositions   *116*

Dynamic Effect of Close-up   *120*

Backgrounds in Composition   *124*

Division of the Picture Plane   *126*

Using Contrast   *127*

Using Repetition   *128*

Creating Depth   *131*

Using Reflections   *132*

Different Compositions of the Same Subject   *134*

Composing from Beginning to End   *138*

Index   *142*

# Introduction

It's hard for me to believe that I have been painting for thirty-two years. It has been a full, varied, and interesting career with a lot happening that I hadn't expected. As I thumb through the visuals of the present volume, I notice how different and how varied the paintings are. I realize how different some of my interests have been and how I have changed through the years.

It amazes me that I am writing a book on composition, since composition is the one area I felt my education lacked. On the other hand, I feel I was lucky in that I had fine drawing and anatomy instruction as a teenager at the Art Students League in New York. I studied drawing and anatomy with the late Louis Priscilla, who in turn was a student of George Bridgeman. My painting instructor was Frank Mason, who still teaches at the League. Frank taught classical realism, which in the late 1950s was difficult to find anywhere in New York City. Strange as it may seem today, realism was scorned in those days by critics and the intelligentsia. One had to be courageous to paint realistically then. I was too young and naïve at the time, too provincial and romantic, to know differently. I knew I was going to be an artist, and a good one, and nothing else mattered.

In my quest to learn everything—and everything included what there was to know about placement and composition—I read whatever I could find on the subject. The most exciting reading I came across was an older book called *The Elements of Dynamic Symmetry* by Jay Hambidge. I found this book very knowledgeable and inspiring, but for me it was impractical to use and incorporate into my paintings in a tangible way. So I was on my own and the information, thoughts, and suggestions I have included in *Intuitive Composition* are basically my own. If there is one thought I would include from our book and place into this introduction, it would be to trust your instincts, trust your intuition, and get as many "shoulds" out of your head as possible.

This book is designed so that you can either read it from beginning to end or thumb through it, stopping at any section, reading only that section, and still come away with a feeling of completeness.

We hope this volume—with its pictures, its thoughts, and ideas—inspires and informs you and that it helps you with your own ideas, works, and creative process. If it does this, then the book has surely been a successful endeavor.

ALBERT HANDELL
LESLIE TRAINOR HANDELL
*Santa Fe, New Mexico*
*November 5, 1988*

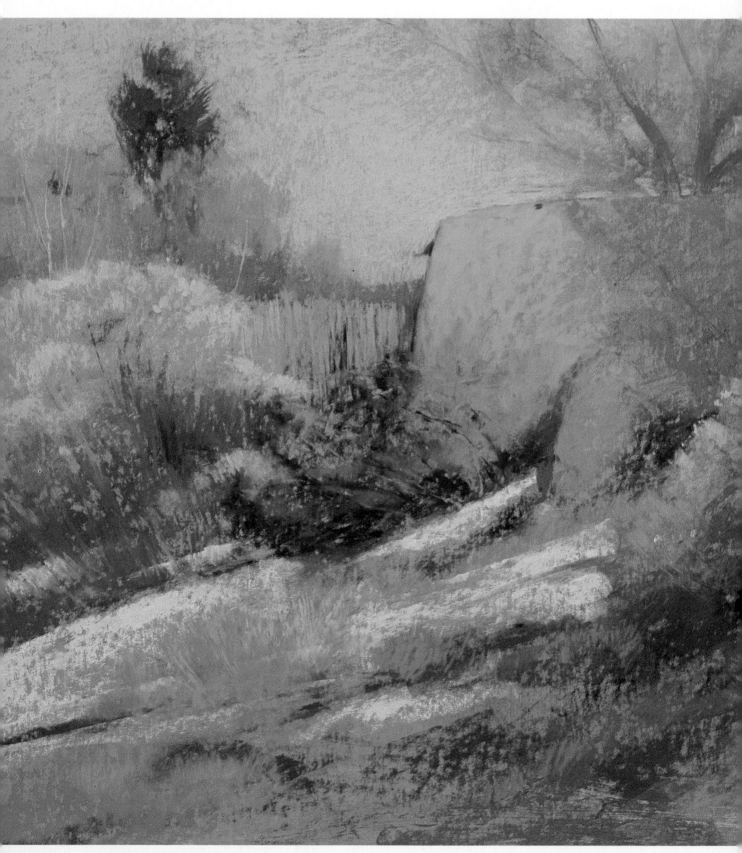

# *Part One*

# SEEING COMPOSITION

*"Allow your feelings and sensitivity to flow freely at all times. Paint only what inspires you. Continue to develop your ability to see, which in turn will develop and enhance your intuition. Strong designs and good compositions will result."*

# Seeing

For children, the world is filled with endless new visual experiences, each one totally unique. Children see more, are more observant, and are more excited by what they see. They haven't formed those preconceived notions about the function and classification of objects in their lives; they simply see them.

What seems to happen as we grow older is that seeing becomes dulled. We begin to look in a practical manner just to get enough information to function. We know where the doorway is so we don't walk into the wall. We spend more and more time mentally running around, looking at one thing, thinking of another. Artists, on the other hand, are most often people who have somehow retained that unique, natural visual ability of the child and see in a special way, seeing more than the average person.

Today, there is new awareness of how artists see and with our present understanding of right- and left-brain functions, special visual abilities can be developed and nurtured. Many artists have striven to train themselves to be more childlike in their vision again. Artists also understand that what they are seeing is a powerful momentary experience, and know that it is also directly related to the abstract. Mentally the artist begins to draw, paint, and compose intuitively all the time.

Most of us do not compose when we "look"; we are not "seeing." Basically, we see details, small parts unrelated to the whole. This type of vision blinds a person from seeing the "unseen" qualities that actually exist. For example, when "looking," we may see just a tree and some details. But the artist's vision is aware of a dimensional whole, of how the tree relates to what's behind it, in front of it, or alongside it; to the sense of space or atmosphere in between the objects being viewed; to the beauty of the light; to the sense of weight of the trees, etc. The artist "sees" and "composes" all the time. This is the basis for intuitive composition.

Seeing compositions, sensing them intuitively, can be learned and developed. Not only will it make someone a better artist but it can also enhance a person's daily experience. In practicing seeing, allow your eyes to wander over your subject matter. Visually caress what you are looking at. Try to get everything else out of your mind. Realize there is a wholeness, but try not to stare or strain to see everything at once. When we are relaxed and not self-conscious, we are more in touch with the moment and we experience things more. We live more of what we are seeing and it becomes a thrilling experience.

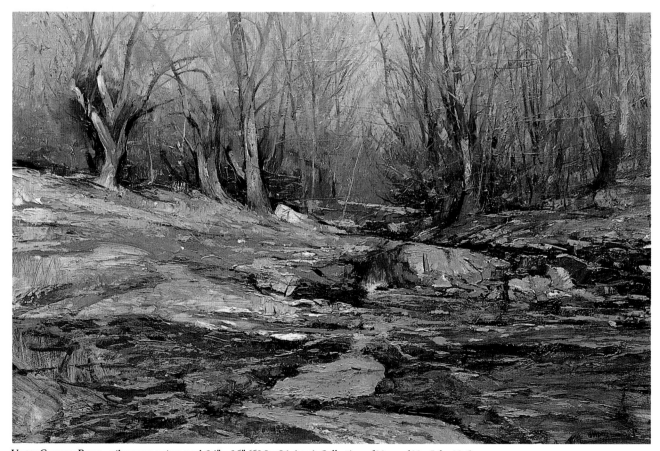

UPPER CANYON ROAD, *oil on masonite panel, 24" x 36" (60.9 x 91.4 cm). Collection of Mr. and Mrs. John McCune.*

## Seeing Rhythms and Movement

The longer I paint, the more I see in terms of rhythms, flows, and movement. Rhythms can be defined as movement but not necessarily motion. A tree or a group of trees is a good example of what I'm talking about. Trees are stationary, but there's such a flow to them, such beautiful movement, such fabulous inner rhythms throughout.

There is an innate duality to everything in nature, and to me rhythm is a reflection of this. Objects are simultaneously stationary and in motion. We are able to perceive the essence of this motion as rhythms, the quiet sense of motion in objects as seen through the shifting patterns of sunlight and shadows, the proportional relationships, the colors and textures, all enhanced by the inner silence of existence. More and more in my paintings I strive to make this aspect of life a reality and an integral part of my artistic expression.

## The Zen of Seeing

What I call the zen of seeing began for me when I was painting on location in the deep woods of the Catskill Mountains. I loved spending the day out in the woods, and I often hiked in the mountains along the streambeds. At times I would leave my paints home. I would hike and then stop and rest to just look at things: the rushing water; the pools of water; the multicolored rocks; the twisting, growing, young light-colored saplings; the strong dark pines and shifting light. All formed a kaleidoscope of visual pleasure. As I rested, I would look at an area as if I were painting it. But I had no materials with me. So I started to make visual paintings. I would look at a rock wall and imagine the color of it al-

ready mixed on my brush. I would visualize my brush applying paint in a certain direction. Then I would go to other areas of my imaginary painting, with different colors on my brush, my brush going in still different directions to bring out the varied textures of underbrush or rocks. While doing this, I would observe the change in my breathing. I would feel very relaxed. There was no anxiety. My ego was at rest and I felt close to ecstasy.

I liked this type of painting. Much to my surprise, in future painting sessions, these experiences would come up and be very clear. At first I thought I might be kidding myself, for there were no

problems. I thought I might be skirting matters or deluding myself. But I continued to allow myself to do these visual paintings, spending a few minutes working on an imaginary painting. I felt wonderful. I felt centered. I began to use this technique before I started my actual paintings. I would spend three or four minutes just looking at my subject, placing it onto the painting surface, visually painting it and getting centered. After just a few short minutes of visualization, I was ready to paint. The painting would flow easily, much more easily than if I had skipped this process. So I became aware of giving my intuition the freedom to guide me.

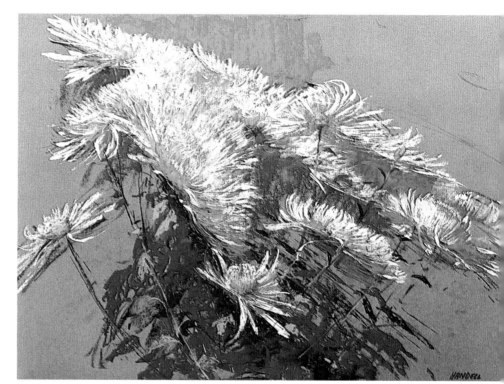

Fuji Mums, *pastel on sanded board, 15⅛" x 21¾" (38.4 x 55.2 cm). Collection of the artist.*

13

# Perception and Personal Vision

Visual perception is the essence of good, realistic painting. It is seeing, feeling, and expressing as an artist does from that special state of creativity.

Visual perception is related to one's personal feelings and preferences, to one's memory and accumulated past experiences. Your personal makeup and interests are part of your sense of perception. For example, a person preferring city living will not see the same things as a person living in a rural area will. Each has heightened powers of perception related to his own familiar environment. Therefore, you can consciously heighten your sense of visual perception by becoming familiar with your subject matter and how you paint it through your own aesthetics and use of medium.

Memory and accumulated past experiences become part of the uncon-

scious, and they are then translated into shapes and colors that become subjective. In turn, this relates one's visual perception directly to the unconscious, the intuitive, and the imagination. Imagination is interwoven and closely related to memory; in part it is a reshaping, or recombining, of memories in new and different ways. A key then to the intuitive and to visual perception lies in the unconscious, which can help you learn to see shapes and their relationships.

To sharpen visual perception, let the intuitive, the unconscious, take over. Try to be open to the flow of what you are visually experiencing and feeling. Your educated eye and your intuition will bring forth good drawings and good designs, full of feelings and sensations that will enhance your capacity to strive for intuitive composition. This will lead you to your personal vision.

A Summer's Moment, *pastel on sanded board, 15½" x 21¾" (39.3 x 55.2 cm). Collection of Rosalie Golser.*

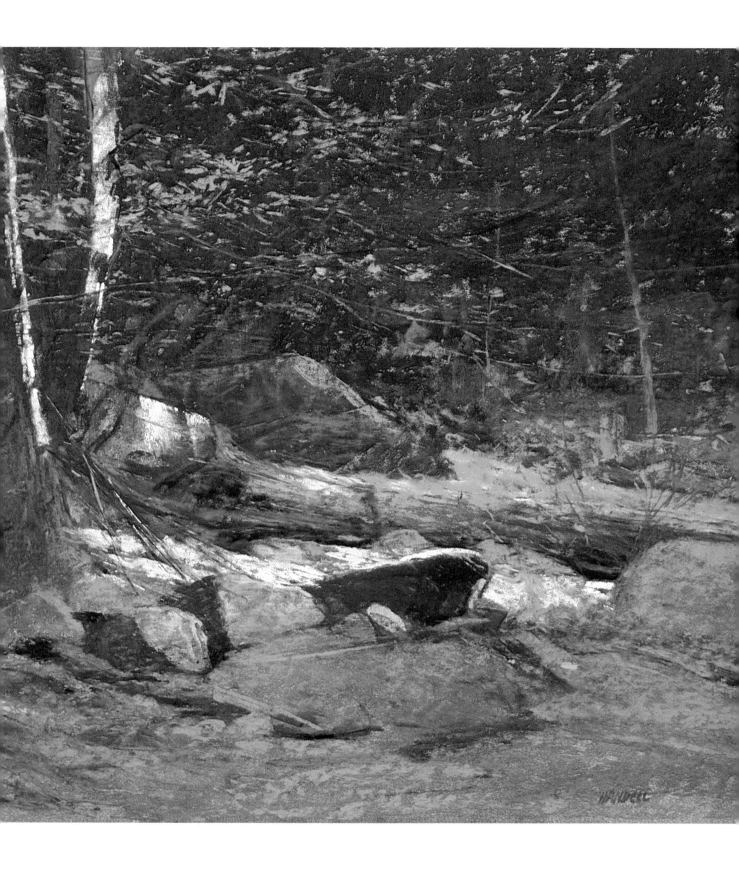

# Reality and Artistic Vision

The artist's visual response to his subject matter is immediate; it is also instinctive and subjective. It is important to realize this. An artist does not need to alter the reality of his subject arbitrarily. An artist internalizes his subject matter and then expresses his feelings about it. Even if he consciously alters something, it is not arbitrary but comes out of a deep feeling and involvement with the subject matter and what it says to him. The sensitive artist will always come up with something individual and special, predicated on his response to the reality of his subject. It will be his own interpretation, his own artistic vision, or way of seeing and relating to the subject and relating to his own painting abilities and techniques. Even if artistic license is used, the subject will always be interesting and personal. It will always have a sense of reality to it when the intuitive response comes from deep within the artist.

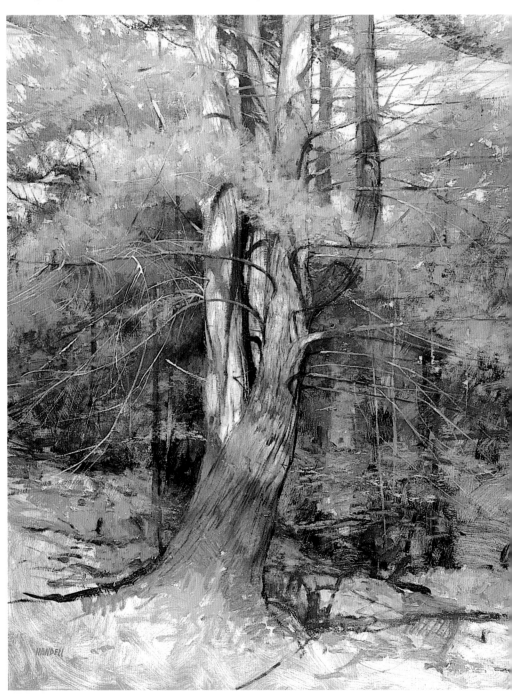

THE WHITE PINE, *oil on masonite panel, 30" x 36" (76.2 x 91.4 cm). Courtesy of the Ventana Gallery, Santa Fe, New Mexico.*

# Simplicity, Harmony, and Balance

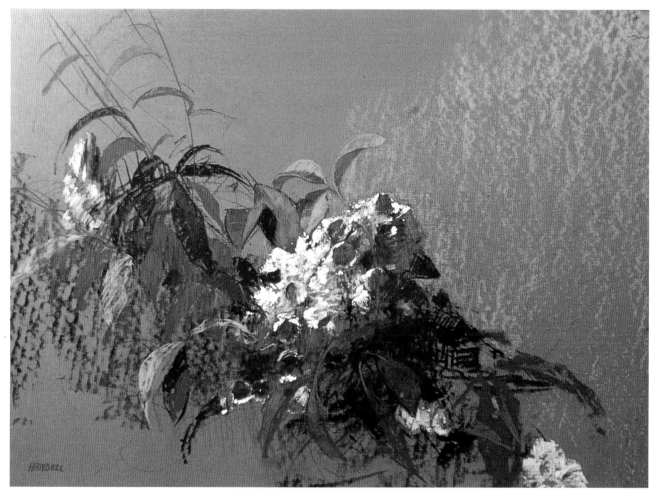

Simplicity relates to the deep inner feelings the artist has about his subject matter. His clarity of expression of this feeling, his organizational abilities, and what he wishes to convey come through as the one main quality or idea that is represented and takes precedence over all the other aspects of the composition of the painting. This simplicity can be expressed, for example, as one object in a vignette with nothing else in the composition to detract from it or as a unity of diverse elements that support but do not detract from the simplicity and clarity of the main idea.

Harmony in a painting refers to the flow among all the elements combined and expressed into the simplicity of the main motif. Harmony also relates to the use of color and tone in the painting and how the artist has maintained a harmonious flow through their proper use.

Balance in the composition of a painting is something that is seen and felt. It does not necessarily mean that what is on one side is on the other or that what is above is below as in symmetrical composition. There are many possible compositions, and an integral sense of balance is achieved through the sense of simplicity and the harmonious placement of the elements of composition—shapes, forms, colors, etc.—into an integrated visual whole.

MOUNTAIN LAUREL, DETAIL, *pastel on sanded board, 16" x 22" (40.6 x 55.8 cm). Private collection.*

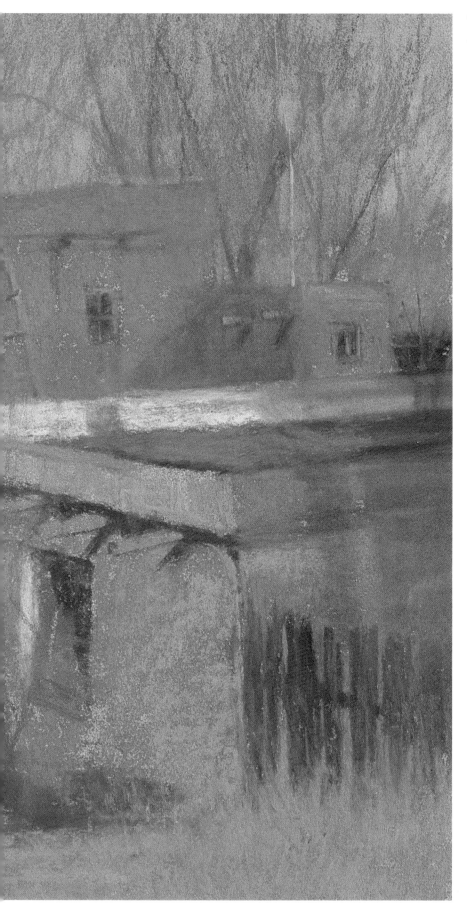

GUEST HOUSE, *pastel on sanded board, 11" x 16" (27.9 x 40.6 cm). Collection of Joyce Rumsfeld.*

# Realism and Abstraction: The Appearance of Reality

In realistic painting, there are usually two visions, or images, that overlap each other. One is the image of the surface realism; the other is the image made up of the underlying abstraction of the surface realism. These two images merge and are what makes up the strong realism and the design elements of the composition. With practice, they can be seen separately, but they are not really separate because they are continually interwoven and influencing each other.

The surface realism seems obvious. It is something that can be looked at, referred to, appreciated, and remembered. A realistic painter, when working from life, has this reality in front of him to guide him, but what he is actually painting is an abstraction, an appearance of this reality. It is a resemblance of trees, houses, rocks, or people that relates to his own experiences, feelings, and painting abilities. Every realistic painting is an abstraction to the extent that it uses abstractions of the shapes and patterns of the surface reality to unify and strengthen the basic underlying structure of the composition of the painting into realistic, recognizable objects.

A realistic painter only uses subject matter, even when he is trying to copy it. And only when it has become deeply a part of him can he persuasively express the reality, the true reality, of his abstractions. In actuality it's his abstract interpretations of the surface reality that add the strength, vitality, and personal vision to his painting. By trusting his design abilities, his inner self, his intuition, and his personal painting abilities, an artist's own individual style results. And after many years of dedicated work, his personal vision develops and surfaces.

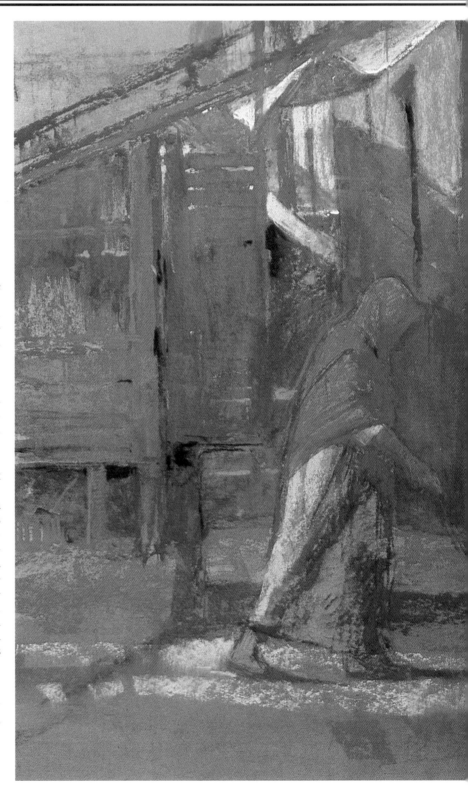

STROLLING, SAN MIGUEL DE ALLENDE, *pastel on sanded board, 16" x 22" (40.6 x 55.8 cm). Private collection.*

# Intuition and Feeling

A strong realistic painting is a combination of the more technical aspects of painting, such as the drawing, the light and shade, correct proportions, placement, shapes and color relationships, the exciting organization of the values, etc. These technical aspects, which are so beautiful in realistic painting, actually come from intuition and feeling, from the subjective. They come from the feelings the artist has about his subject and the depth of his involvement with it and from his paint medium.

Intuition is subjective and depends on feeling, on what attracts you, and what you go after. Much of intuition is also related to memory and perception. Past experiences become so much a part of you that when you are in touch with them and recall them, you respond emotionally. This forms the basis of intuition in painting.

Surprisingly, you will find that after a while you are drawn to subjects that you will return to regularly. All artists are. What makes each artist unique is that he discovers himself in the subjects he's drawn to. All artists then make use of the same basic tools of artistic expression that have become a part of them. But they feel them and use them intuitively in their own unique way, which is their own unique vision, their signature. The subjects you personally respond to emotionally with poetry, intuition, and feeling will surface time and again based upon your own commitment and experiences, and will become part of your own unique vision.

Really feel your subject matter out and realize what you want to express about it. The clearer your feelings are, the stronger the painting, and the more your intuition will guide you. Working in this way with feeling and intuition will always give best results.

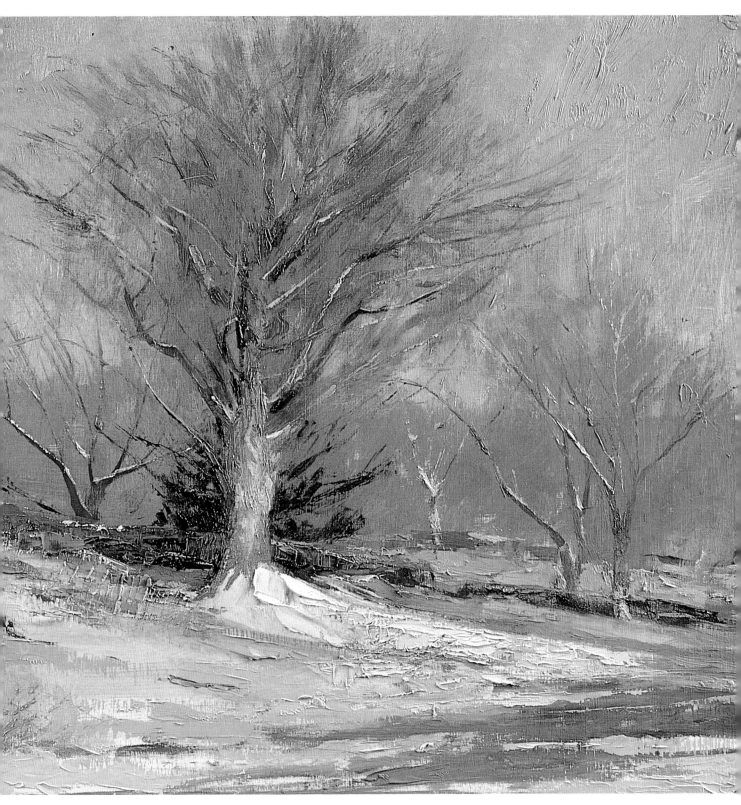

WINTER MAUVE, *oil on masonite panel, 20" x 24" (50.8 x 60.9 cm). Collection of Dr. and Mrs. Randel A. Patty.*

# Part Two

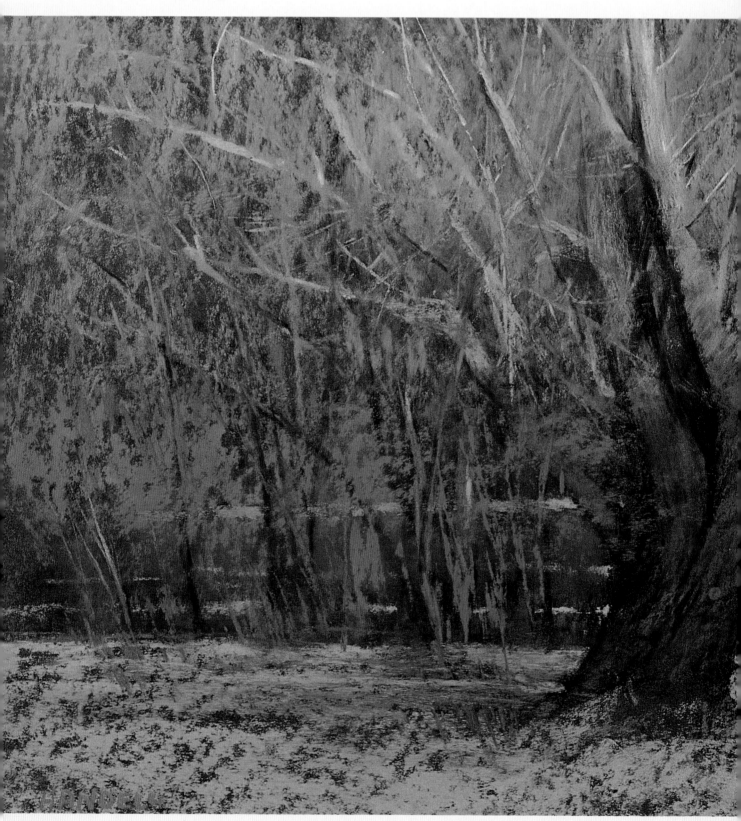

# ELEMENTS OF COMPOSITION

*"You can spend a lifetime painting the things that interest you, just a few subjects that have deep meaning and value, without ever exhausting your interest.... You may then drop this interest happily or reluctantly and go on to a different interest or set of themes, which can also last for years. This is part of the creative process and individual uniqueness...."*

# Shapes

Everything has a shape. Shapes are terribly important. Without them, strong realistic painting doesn't exist. Shapes show how objects occupy space and how the essential characteristics of the object are perceived by the viewer. In realistic painting, shape is defined or composed by the visible parts of an object, that is, by what can be seen of an object or objects from a fixed or particular point of view. In turn, objects can also be defined by the shapes.

Objects considered as shapes and their relationships to each other come first in creating a composition. They are interwoven with the objects.

An important aspect of these shape relationships in realistic painting is seeing, as discussed earlier. Seeing objects as shapes and seeing the shapes within the composition requires a different vision from the vision that stares at details. I usually squint my eyes to see past the detail and to see the shapes more clearly.

The shapes are three-dimensional and in the composition of a painting, they are enclosed within designated areas by edges or lines that are two-dimensional. Lost and found edges profoundly affect the reading or seeing of the shapes. This process creates the illusion of three dimensions, which always includes two-dimensional shape relationships worked out to show the three-dimensional shapes of the objects.

Shapes and relative shapes can certainly be one of the most important elements of a painting. Their positioning alone and together, their action, balance or imbalance, even directional thrusts all can create immense spatial variety in compositions.

Clarity of the shapes is essential for good composition. Underlying shapes must be clear so that objects are easily recognizable.

The major shapes are established fairly early in the painting and should retain their clarity and integrity in the composition right until the end. Sometimes just one or two major shapes is enough. Subordinate areas may have other shapes in them, but they should not detract from the main shapes.

However, not every shape of every object needs to be as specific as every other shape. Some can be left vague with only enough definition for the viewer to become involved and conjure his own images. This will allow the eye to move through the composition from specific areas to suggested areas.

The activity of the shapes changes in relation to how and where they are placed in the composition. Alive interesting shapes will usually create an alive interesting composition arising out of the life of the shapes themselves and their relationships. Echoing shapes can create overall patterns in the composition of a painting. Repetition of certain shapes can create interesting possibilities for subtle variations later on. Introducing new shapes will tend to add a sense of movement and countermovement to the composition. And when they are solidly structured and harmonized, the shape relationships balance the composition.

The type of shapes and their arrangement could also determine the mood of the entire painting. Shapes can be exciting, original, and obvious or subtle and hidden, but usually they all have very expressive personal qualities to them. How the shapes are related and positioned in space gives meaning and feeling to your personal visual expression.

My paintings are not begun with the idea of the geometric forms of shapes first. Rather, when the basic composition has been established (which includes establishing the center of interest and its placement), the geometric patterns become apparent and the forms are integrated to make the whole. The shapes evolve.

I feel shapes are basic emotional symbols that carry a powerful impact and that there is a strong unconscious power in them that should not be ignored. How to become aware of unconscious already-existing intrinsic shapes; how to respect them and nurture them; and how to allow them to emerge calls for great care and sensitivity to them. They will emerge. They are part of your unconscious. That is what you want to tap. It's already inside of you.

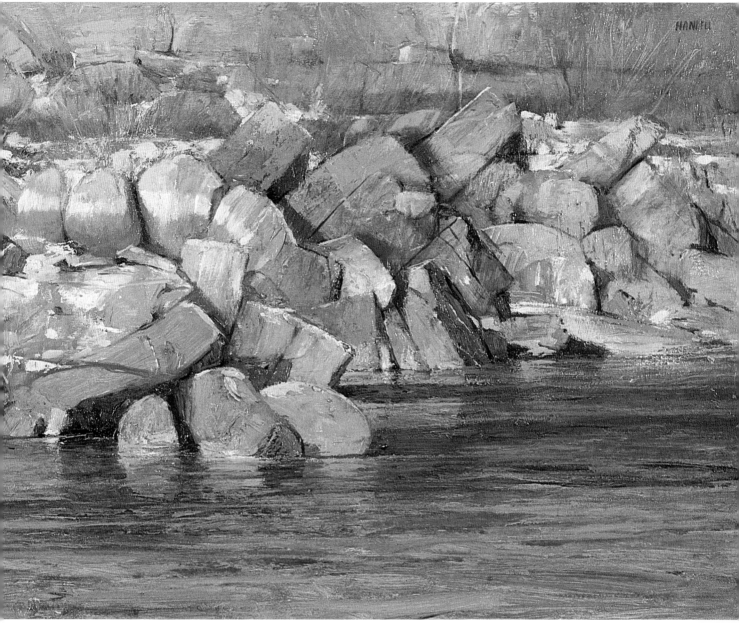

ALONG THE RIO GRANDE, *oil on masonite panel, 14" x 24" (35.5 x 60.9 cm). Courtesy of the Ventana Gallery, Santa Fe, New Mexico.*

The shapes in this painting are simultaneously complex and simple. The tightly inter-locked arrangement of the rocks gives a sense of their arbitrary clustering along the Rio Grande. Yet notice how the painting is practically divided into horizontal thirds. This gives relief to the array of complex shapes and colors that make up the rocks. The water, very green in color, flows horizontally through the lower third of the composition. The top third of the painting, basically a darker blue gray, also has a strong horizontal movement to it. This works very well as a background for the helter-skelter shapes of the rocks, which constitute the center of interest. Much work, detail, and love were painted into the rocks. Their elusive shapes and their changing colors and values further a certain subtlety in the painting.

FRIDAY MARKET, *pastel, 18" x 24" (45.7 x 60.9 cm). Collection of Dr. and Mrs. Vernon Filly.*

Here is a composition in which the shapes of all the objects are obvious and can be easily read. Squint as you look at the painting to lose sight of the details, and the shapes will be easier to see. The center point is the woman's portrait which is an oval shape. The woman's entire body is also oval in shape. This oval within an oval is surrounded by squares and rectangles and horizontal and vertical lines going every which way. All of these shapes together make up a very strong interlocking composition. The rich colors defining the shapes also help to bring out the warm light that prevails throughout this painting.

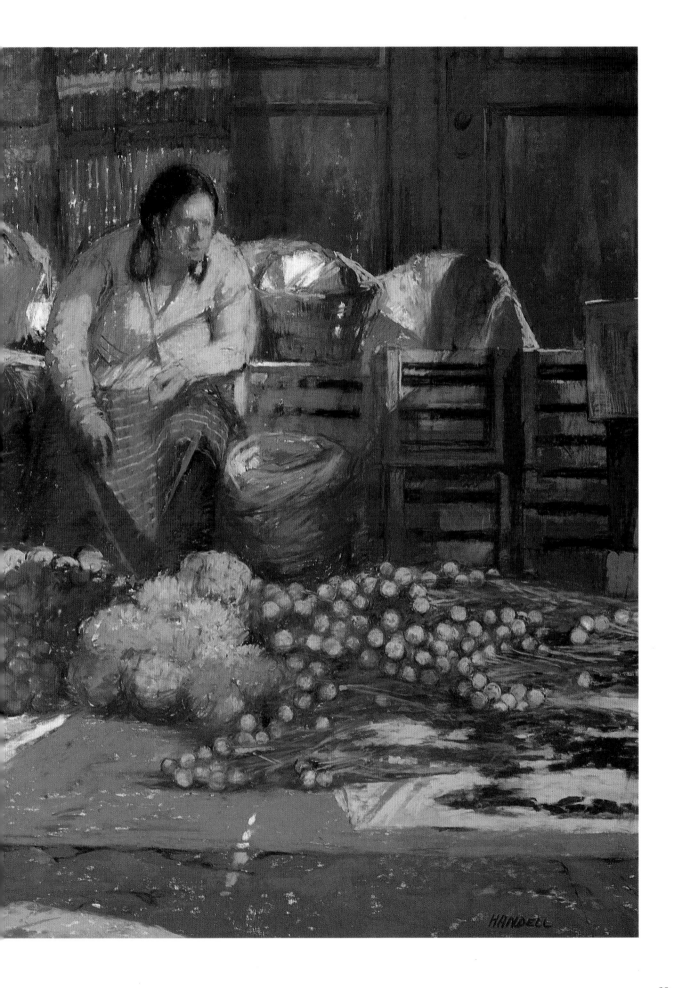

# Patterns

Patterns to me are an elusive aspect of realistic painting. They do not always have definite shapes, and they are not always actually seen but are sensed and felt. What they are is usually two-dimensional and flat, a unity or grouping together of shape or direction, used in subtle combination with other elements of composition to create the sense of three-dimensional space.

Left alone, patterns themselves do express depth. They do express geometric forms, symmetry or asymmetry, free-flowing movement or repetition of similar elements. Or patterns can simply be felt even if they are not delineated. They can be created by subtle implied lines of diagonal, vertical, or horizontal movement, completed by the eye of the viewer.

For me, using patterns effectively is a very important compositional element in realistic painting. They allow you to read something realistically that is basically painted abstractly or suggestively. Patterns suggest the realism. The realism is not painted literally, but it is through the patterns and the abstraction that the realism is perceived by the viewer.

THE STREAM, *pastel, 16" x 22" (40.6 x 55.8 cm). Private collection.*

This painting was an actual demonstration for one of my workshops. I started it by focusing in on the center of interest. In this case, it was the complex angular forms of the foreground rocks and the rushing water. I kept the warmest, richest, strongest colors and the strongest value contrasts in the foreground, along with most of the detail. The background was established later as a secondary consideration. I contrasted and simplified it, keeping it a cool, simple, flat pattern that reads immediately as background trees.

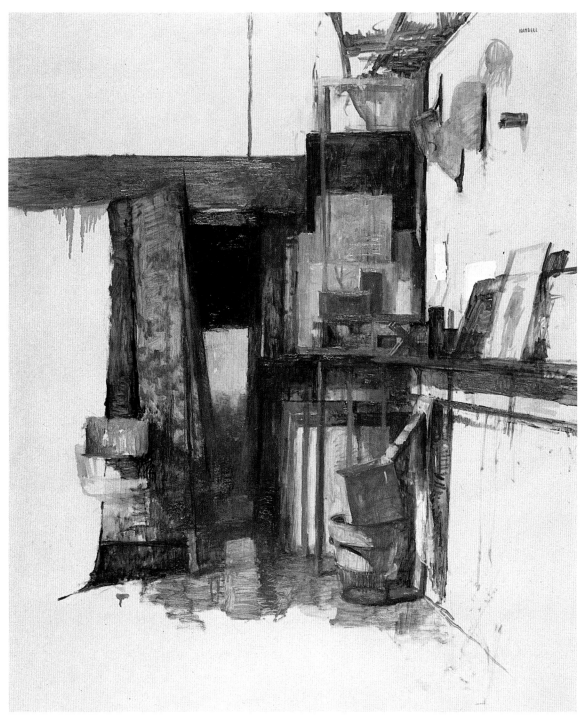

CORNER OF MY STUDIO, *oil on masonite panel, 36" x 30" (91.4 x 76.2 cm). Collection of the artist.*

I have always liked this painting. I had admired the forms and shapes in the corner of my studio for some time, sensing the patterns there. I decided to paint the corner, allowing the shapes, forms, and patterns to show through strongly, establishing only as much detail as needed to let the viewer visually visit the corner of my studio. The vertical pattern running through the painting gives the feeling of that particular corner of the studio, with all its clutter and numerous objects. The entire corner is painted through the relationship of the many rectangles and squares, vertical and horizontal lines and movements, plus selective details. So many of these shapes and lines are repeated and interwoven that the eye sets the whole composition up as being made up of patterns. It's subtle but definitely there.

# Planes

A first consideration of planes in composition is the picture plane. It is the flat surface on which the composition is painted. It is the plane through which the picture is seen. It is the plane on which all of the lines, shapes, patterns, directional movements, etc., are established. It is the basis for the two- and three-dimensional aspects of the composition. The picture planes of a composition show where objects exist in space.

A second consideration of planes in composition is that all objects have planes. They are the elements of the objects that give them form and establish their three-dimensional definition in space. The wall of a building, not receding in perspective, is a flat upright plane. A tabletop is a flat horizontal plane. A portrait is made up of many complex subtle planes—a nose, the forehead, the chin, the cheekbone, etc. It is through the planes that one can observe the form, the sense of the third dimension, the coming forward or receding of objects.

Most often, planes have shapes that are simplified and used in composition to create a sense of depth or distance. Sometimes these shapes overlap; sometimes their direction can express the movement of the composition. For example, a horizontal plane elongates the composition. In the later stages of a composition, adding texture and color to planes creates variety and a greater sense of depth.

I remember hearing the expression often in art school, "Don't forget to plane that off." To me, this still means to get right down to the area you are painting, focus in on it, and get all the different subtle nuances of the planes that exist on that surface. Going after them and defining them clearly is one more strong aspect of solid drawing and balanced composition.

The town of Corrales, which is adjacent to Albuquerque, is composed of relatively flat farmland and ranches. It is quite beautiful. In this painting, because of the slightly lower eye level and the slight dip in the land right behind the foreground trees, we have a composition with basically two picture planes. The foreground trees and land leading up to the trees are part of the foreground plane. Then, zooming in behind the foreground plane is the background plane, composed of numerous buildings and distant trees. Everything in the background plane is suggested by shapes, colors, and patterns. Details are kept for objects in the foreground plane that I want the viewer to focus on. Using picture planes in this way is rather dramatic and strongly shows the third dimension in a composition.

CORRALES, *oil on masonite panel, 24" x 30" (60.9 x 76.2 cm). Courtesy of the Ventana Gallery, Santa Fe, New Mexico.*

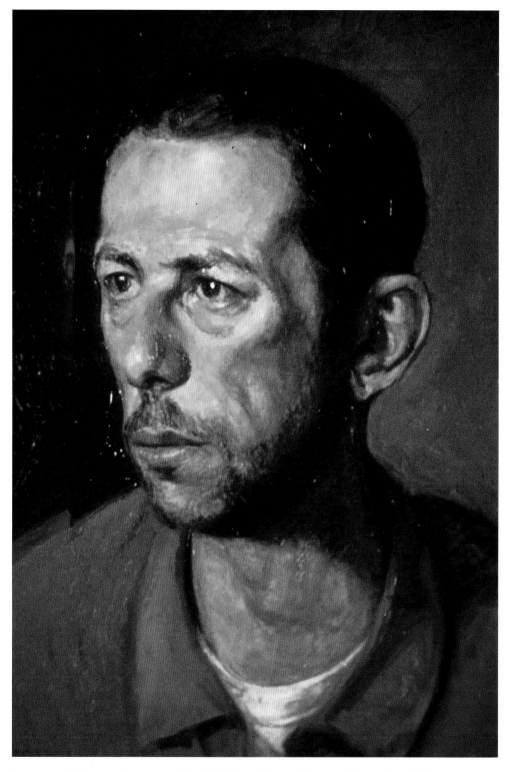

PORTRAIT OF ED SACHS, *oil on canvas, 16" x 20" (40.6 x 50.8 cm). Collection of Mr. and Mrs. Ed Jaffe.*

Here is a simple, yet powerful, in-depth portrait of a friend I met while living in San Miguel de Allende, Mexico. Ed was a writer who had lived in Chicago and had moved to a warmer climate. He loved posing, and I did more than one portrait of him. Life shows in his lean, angular face. The planes of his head show up dramatically and seem to frame and be part of his face. An important part of making this composition was painting the subtleties of these planes and the angularity of Ed's portrait. The eye actually travels on the planes, as they move up, down, and around his portrait, bringing out the underlying bone structure of his skull.

# Positive and Negative Space

The shapes of the positive and negative space and their interrelationships are an important composition principle. The placement of these elements into the format determines the composition.

The space of the positive shapes is composed of the subject matter, that is, the objects or persons that are the center of interest in the composition. The negative shapes are the areas surrounding the positive space.

I like to focus in on the positive space, the subject matter, right away. It is often the area that interests me the most. I tend to look at the space of the positive shapes as areas that can stand out by themselves as vignettes and push and develop the positive shapes to be as strong as possible. I also consider when I am composing space that the positive shapes need not be only the foreground but can be a combination of foreground and background objects tied together to make up a truly complex and subtle positive area.

However, solid, balanced, interesting composition is terribly important to me. I never lose sight of the negative space as I am focusing on the positive

areas. I maintain a sense of the entire painting as I work.

I feel negative space is more subtle, beginning wherever positive space ends. It is the peripheral area, the space surrounding the occupied area. I also feel that the negative shapes are as important in the composition as the positive subject matter and should be given the same degree of attention that's given to the positive space. I realize the positive space could not exist without the negative space that frames it.

When you are composing negative space, remember that negative space is limited by the format of the painting surface. The shapes of the positive space, in contrast, are usually centrally located. Negative space also often needs to be broken up into smaller shapes and then integrated with the balance of the painting. In this process, the shapes that are made up of the negative space evolve into shapes that have distinctive characteristics of their own, equal in importance to other areas. Giving them the same care and attention given to the positive areas of the painting will create strong balance in your composition.

SEDONA, *oil on masonite panel, 30" x 36" (76.2 x 91.4 cm). Courtesy of the Ventana Gallery, Santa Fe, New Mexico.*

*Sedona* is a perfect example of a painting strong in composition. The shapes of the entire rock formation make up the positive space and the sky the negative space. The area of the painting surface given to the rock formation is almost twice the area given to the sky: a two to one proportion that makes an interesting composition.

First, I laid out the painting by establishing the placement of the rock formation. I painted it high in value with warm transparent colors. Later on in the painting, I used transparent and opaque applications as I developed the rock formation.

The negative space, the sky, was painted quite differently. I wanted the sky to complement the rock formation, not to compete with it. Therefore, I kept the area comparatively simple, using mostly one value of purple, varying the color from warm to cool throughout the sky and subtly blending it. The paint was applied opaquely, with the same consistency throughout. The purple complements the foreground yellows and oranges. In the lower part of the rock formation, some purple tones creep into the rocks and develop certain planes in them while maintaining the harmony of the positive and negative spaces of the painting.

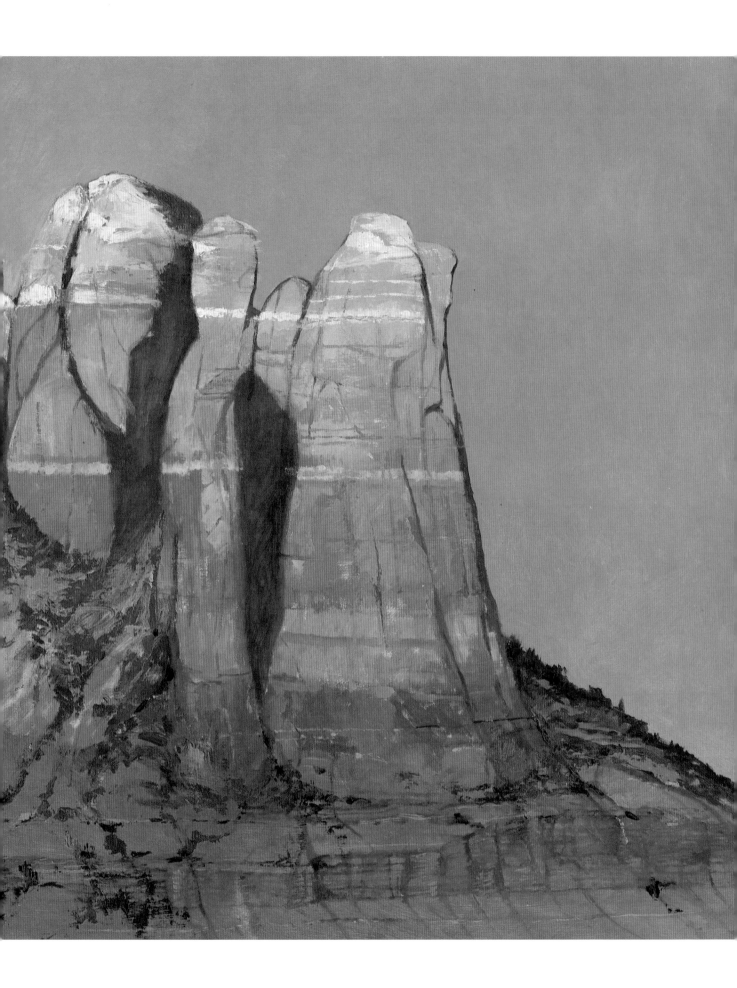

THE ORANGE ROOF, SANTA FE, *oil on masonite panel, 20" x 26" (50.8 x 66.0 cm). Courtesy of the Ventana Gallery, Santa Fe, New Mexico.*

This painting is a bit more complicated because of the composition of its positive and negative spaces. The negative spaces, which consist of the blue sky, are broken up. Since the values of the colors of the sky and the foreground tree are close, they start merging ever so gently, making negative and positive shapes elusive. By means of the foreground road, the light-colored snow, and the dark bluish cast shadows, the eye becomes engaged in the composition, exploring the many suggested details up to the middle foreground buildings and trees.

To better appreciate the subtlety of this painting, try to analyze the negative and positive shapes. Start with the baseline of the adobe buildings on the left, which leads right into the baseline of the coyote fence on the right. Notice that this is practically a straight line. Focus on this area and consider all the buildings and trees above this line as one shape, one foreground mass, the positive area. Consider the sky holes as constituting negative areas. Notice how the blue of the sky is broken up into different shapes—left, right, and beneath the dark rich green of the center tree. Squint your eyes and try to pull out these shapes. Abstract them and try to look only at these negative shapes to see what you come up with.

# Empty Negative Space

As stated earlier, negative space is most often broken into smaller shapes that balance with the positive space, once the placement of the subject matter is established. This balance establishes an underlying structure that gives the painting more solidity and strength.

However, this balance with the shape of the positive space or subject matter can also be achieved by leaving the negative space empty and composing it into one dominant, vital geometric shape.

Empty space is usually a secondary consideration in composing a painting, though this is not always the case. It can be a powerful compositional element that adds a great sense of depth. Careful consideration of where you place your subject matter is very important when dealing with empty negative space. The placement on the surface of the center of interest automatically gives you the shape of the empty negative space.

It takes a relaxed frame of mind to concentrate on empty negative shapes. Using empty negative space in a composition can be very beautiful and powerful. This is exhibited most often in the paintings of Oriental masters. They are masters of balancing empty, negative space because their training teaches them to absorb the composition of the entire painting surface at once. Their tranquil and reflective approach to painting contributes to developing this ability. It also contributes to developing a great intuitive sense of placement.

Following are two examples of different subject matter with empty negative space. The white background of the paper is composed into the surrounding geometric shape.

The gas pipe itself is an object of complicated shapes. I had wanted to paint only the gas pipe; the background didn't interest me. Since I decided to leave the white of the paper to work as the empty negative space, the placement of the gas pipe on the white paper was crucial. I was sitting on a stool, and the gas pipe was on a table that had a white tablecloth. My subject was slightly below eye level. I wanted to get the sturdiness and sense of weight into the painting, as well as the shapes, colors, light, and shade. Therefore, I placed the base of the gas pipe (the part of the gas pipe that is sitting on the tabletop) low on the page. That placement, plus the strongly established cast shadow, solidly situated the gas pipe in the space.

THE GAS PIPE, *watercolor, 7½" x 9" (19.0 x 22.8 cm). Collection of the artist.*

PORTRAIT OF NEIL, *pencil and pastel on sanded pastel paper, 12" x 15½" (30.4 x 39.3 cm). Collection of Dr. Susana Bouquet Chester.*

I had the opportunity of doing a pastel drawing of a very interesting character. Neil was very wired-up, quite nervous, and really couldn't sit still for a long time. I had to work fast, I knew that, and the instinctive placement of his portrait onto the page was important and had to be right; otherwise the feel of the portrait would be weak, no matter how accurate I was with it.

The empty space around the portrait had to be sensed and considered. I decided to work horizontally rather than vertically, establishing the placement of the portrait higher onto the page. The head is tilting to his right, but the eyes are looking to his left. I didn't want to establish the head too much to the left or right of center since Neil's hair was wild and unruly and I wanted enough room to allow for the luxury of his wild hair, which is so definitely part of the portrait. The rest of the page, left untouched, works as one dominant vital shape of empty space, making the portrait feel more voluminous. It's as if one could put one's hand around Neil's head. Here, the empty space works beautifully for the form of the portrait and for the short time available in which to work.

# Types of Movement

Movement is energy. It is integral to composition. It can be the backbone of certain compositions or it could quietly weave through a composition. Movement in a composition determines how the viewer's eye travels into, through, and around a painting.

I compose my paintings in response to my subject matter. I see a particular movement that attracts me and determine as I compose the painting how to bring this out. This is part of composing.

Some of the main types of directional movements we consider in compositions are horizontals, verticals, diagonals, and curved and circular movement.

Opposing angles and combinations, and symmetrical and asymmetrical movement, are outgrowths of combinations of these four basic directional movements of composition.

## Horizontal Movement

Horizontal movement relates to the parallel plane or level of the horizon and reaffirms the dominant horizontal directions of the painting surface. A bare canvas placed horizontally gives a sense of solidity because of its broad base. Horizontals also give an expansive feeling, and a painting composed through horizontal lines will make the shape of the canvas look even longer horizontally.

Horizontal movement is used very often in the composition of paintings and works very effectively. It is a stabilizing and unifying type of composition. Many times the horizontal lines of the composition are obvious. At other times they are hidden and weave in and out of the subject matter. They also tend to divide the areas of the painting horizontally.

Horizontal compositions give a sense of flat space and depth. They usually lack movement and are more static and

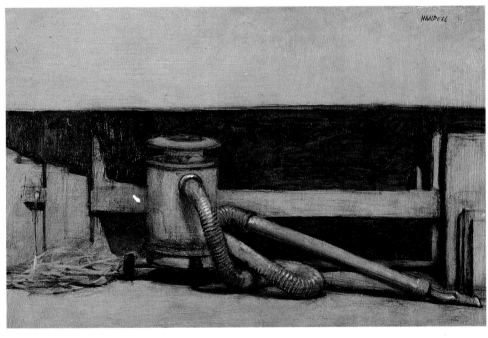

THE VACUUM CLEANER, *pencils, turpentine, and yellow oil color on prepared masonite panel, 12" x 18" (30.4 x 45.7 cm). Collection of Mr. Peter Cousins.*

I wanted to get the fullness and roundness of the forms of the vacuum cleaner and all its parts, including the yellow extension cord. I thought of the hose as a large fat snake, winding its way from the front of the vacuum cleaner and ending alongside it. To frame this object, I decided to use strong horizontal lines, with the major line being the line just above the vacuum cleaner that cuts the picture plane dramatically. Everything above that line, which is two-fifths of the entire picture surface, was left blank, except for my signature in the upper right-hand corner. All complexity was kept below this powerful line, which represented a shelf above the radiator. It threw a strong cast shadow that I abstracted and established simply. There is a piece of wood that goes from left to right on the radiator directly behind the vacuum cleaner. I kept it as a horizontal line to break up the background black cast shadow in an interesting way. Uprights on the right-hand side that break up the horizontal lines were several painting panels leaning against the radiator. On the left-hand side, an electrical outlet and an extension cord hanging down from it are subtle but important verticals.

restful. Subjects that lend themselves to horizontal compositions are numerous. Water or land, which both lie flat, reclining figures, and still lifes are among these. These types of subjects can often convey a sense of peaceful tranquility, the feeling of which is emphasized by a horizontal composition.

Movement is part of a horizontal composition by use of angles, subjective lines, or significant edges. Selective use of added elements will also keep the eye in the painting—necessary in horizontal compositions, which have a tendency to run off the picture plane to the right or left.

Horizontal lines can be used for very dramatic effects. A good example of this is the watercolor *The Red Berries*. Contrast these horizontal lines to the simultaneous effect of rest and movement in *Woodstock Stream*.

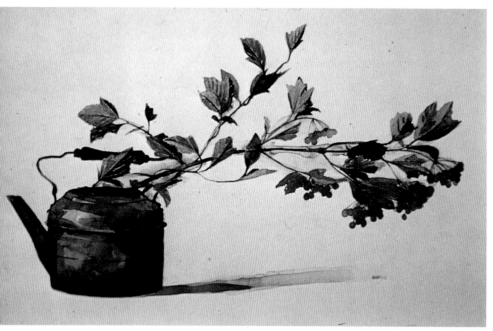

THE RED BERRIES, *watercolor, 8" x 14" (20.3 x 35.5 cm). Private collection.*

Above, the horizontal line of the twig is used as a dramatic cord that pulls the eye to the right to where the red berries are. The teapot that is used to hold the berries is placed as far to the left as I might dare. Without the long horizontal line of the twig, I could never have placed the teapot where I did. The composition simply would have appeared unbalanced and the teapot misplaced. With the teapot situated where I had placed it, I would have had to cut off a section at the right side of the paper to achieve a balanced composition. But I sensed the power and strength of the horizontal line, and in placing the pot as I did, I obtained a truly different and unique composition.

WOODSTOCK STREAM, *oil on masonite panel, 13" x 23½" (33.0 x 59.6 cm). Collection of the artist.*

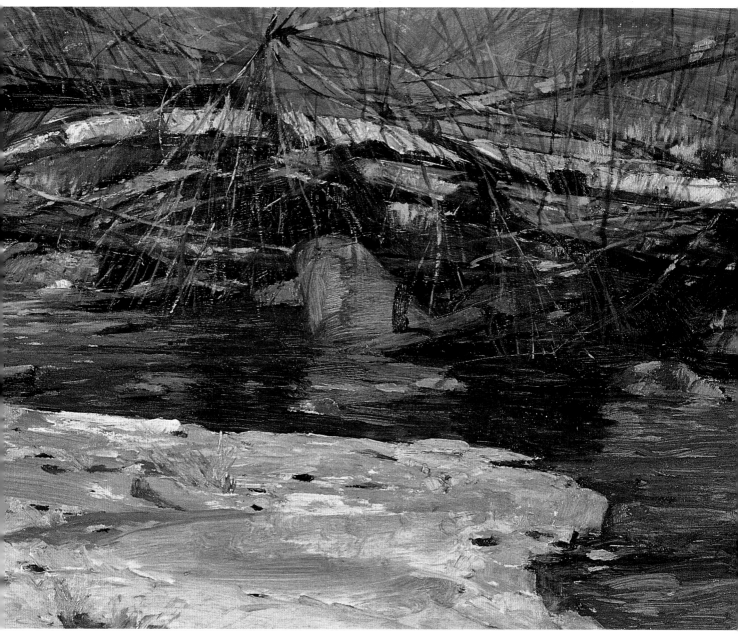

In this composition the use of horizontal lines is subtle because the lines do not go from edge to edge. Follow the white fallen birch tree that starts on the right. Above it is another dark line—the dark trunk of another fallen tree. Underneath the birch is the trunk of still another tree, which goes all the way to the edge. Then, underneath the branch to the right of center, is a clearly defined rock. To the left of that rock is another horizontal line in the form of another fallen tree moving toward the left but not touching the left-hand edge of the canvas.

All the horizontal lines of the fallen trees touch or start from the right-hand side of the canvas, or feel as if they do. The long rectan-gular shape of the canvas adds to the horizontal feel of the compo-sition. Since I wanted the eye to go into the painting, I let the left-hand portion of the composition remain open. There, the stream flows into the background.

I dealt with the land area, where I was standing, painting, by us-ing lighter values and more red and purple tints. Notice that this area works horizontally also. Starting from the left, the line of the land keeps the stream above it on its way into the painting. But it goes on a slight angle, which is higher on the left and lower on the right. Later, I opened up this line by curving it down on the right-hand side. In this way, I made the stream flow into the painting.

## Vertical Movement

Vertical movement is an up-and-down movement that is perpendicular to the horizon. It can be prominent and very visible in the composition, or it can be very subtle.

At times, it's upright pull is forceful, allowing the eye to climb to the top of the composition. A vertical composition can create a feeling of suspense or a sense of falling, giving a feeling of things about to happen in a painting, creating a sense of inbuilt tension in the composition.

Vertical movement, though it is a movement only on a flat surface, visually relates to and follows the feel and pull of gravity, holding the composition within the top or bottom areas of the composition of the painting. When vertical movement is used alone, it gives a feeling of flat space and can flatten the picture plane.

Vertical movement is so forceful that at times it can become too prominent in a composition, and it may need to be offset by other elements. When the base is too narrow, abundant vertical movement in the composition may create an insecure feeling in the composition, which can give the feeling of being top-heavy or even of falling. Unless this effect is desired, there would be a need to balance these vertical thrusts with other elements in the composition. Most often, however, when vertical movement dominates a composition, it adds a unifying movement, pulling together the shapes, lines, and direction of the composition.

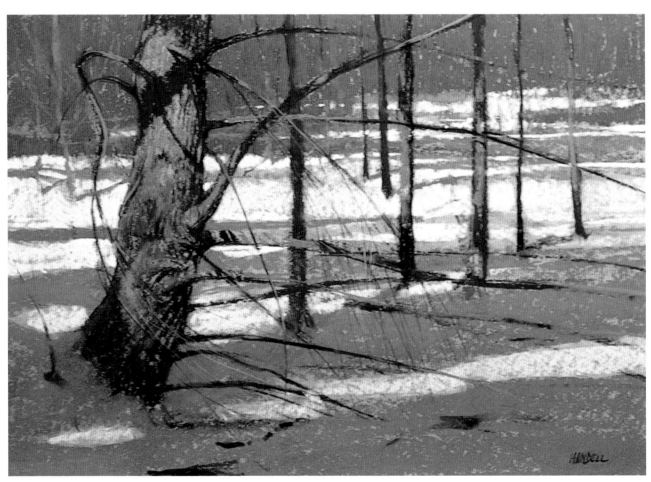

THE TREES IN WINTER, *pastel, 16" x 22" (40.6 x 55.8 cm). Private collection.*

This painting, which I composed and painted instinctively, is a subtle composition. It was an actual demonstration in one of my workshops. This type of design—the vertical movement throughout the composition of trees or houses in contrast to horizontal shapes that bring out the ground plane—gives a strong sense of depth to a composition. I use it often in landscape, varying and repeating the theme. The most prominent tree was placed far to our left. I knew it was placed far too much to the left to remain there by itself. In or-

der for this vertical to work on a horizontal picture plane, I had to take note of the other verticals and all the different horizontal shapes and colors of the composition. For the horizontal shapes, I used three colors: blue gray, off-white, and reddish purple. The arrangement and handling of these shapes allowed them to recede. Since they lie flat, the eye can meander through the verticals of the suggested trees. The echoing of verticals keeps harmony with the rest of the painting.

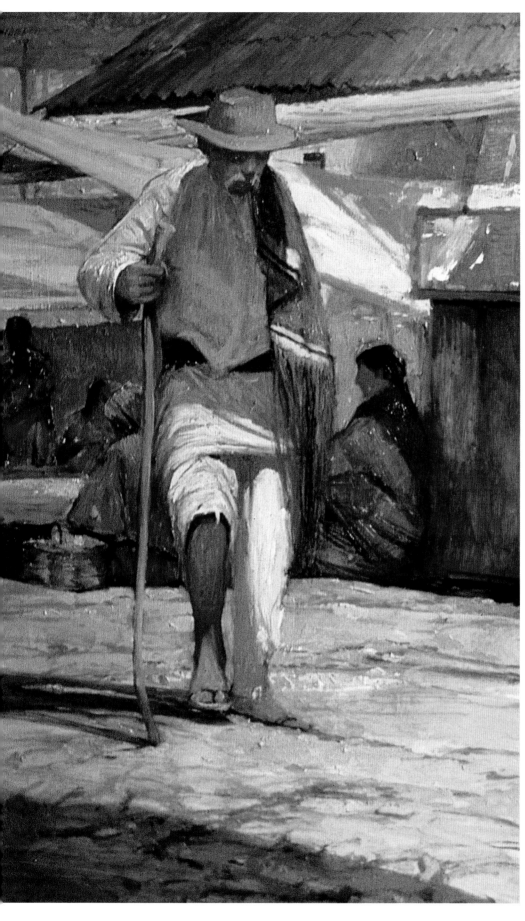

In *The Elderly One* the canvas itself is vertical, and the center of interest is also vertical. Vertical lines are repeated in this painting with the outline that begins at the top of the elderly one's hat and continues down his left side to the green rebozo, down to his left leg. This practically forms a straight vertical line. On his other side, the elderly man is holding a wooden cane that makes a short vertical straight line. Verticals are echoed in the background. Behind the elderly man is a woman leaning against a reddish brown wall. On the other side of the old man, farther in the distance, a vertical is repeated again in the back view of a woman standing.

The vertical movement of this painting had to be balanced. I used sharp horizontal and angular lines that criss-crossed behind the subject to keep the painting from being too elongated, which in the beginning was a problem. Dark, bluish cast shadows were introduced at the bottom of the painting. One of them works very well where the old man's legs are touching the ground. The second one is in front of him and balances the base.

## Diagonal Movement

Diagonal movement is usually a powerful movement in a composition—often the key directional element to movement in many compositions. It has the power to pull the attention of the viewer up, down, or across the painting. It can continuously direct the eye toward the center of interest.

If the diagonal movement goes from the lower left to the upper right, the eye will ride this diagonal movement upward, for we read from left to right and are used to viewing things that way. In like manner, if the diagonal movement starts on the upper left and goes down to the lower right, the eye would be led downward.

Diagonal lines are usually not inconspicuous lines. Unlike horizontals and verticals, they give a greater sense of drama to a composition and can cut or divide a composition strongly. Or they can be used to subtly unite areas.

Diagonal movement is also very powerful in creating *patterns* of movement in a composition. It can accentuate previous directions, lead the eye in a completely different direction, or simply work as an effective wall.

Diagonal movement can help to establish a sense of perspective in a painting. It is a movement or a line that allows the eye to look past it easily into the background or to stay in front of it looking into the foreground areas.

However used, skillful mastery of diagonal movement is a useful tool in intuitive composition.

ZIG-ZAG, *oil, 14" x 18" (35.5 x 45.7 cm). Private collection.*

The flow of the moving water and the zig-zag shape it takes is very powerful. It becomes the central movement in the entire composition, leading the eye into and out of the picture plane.

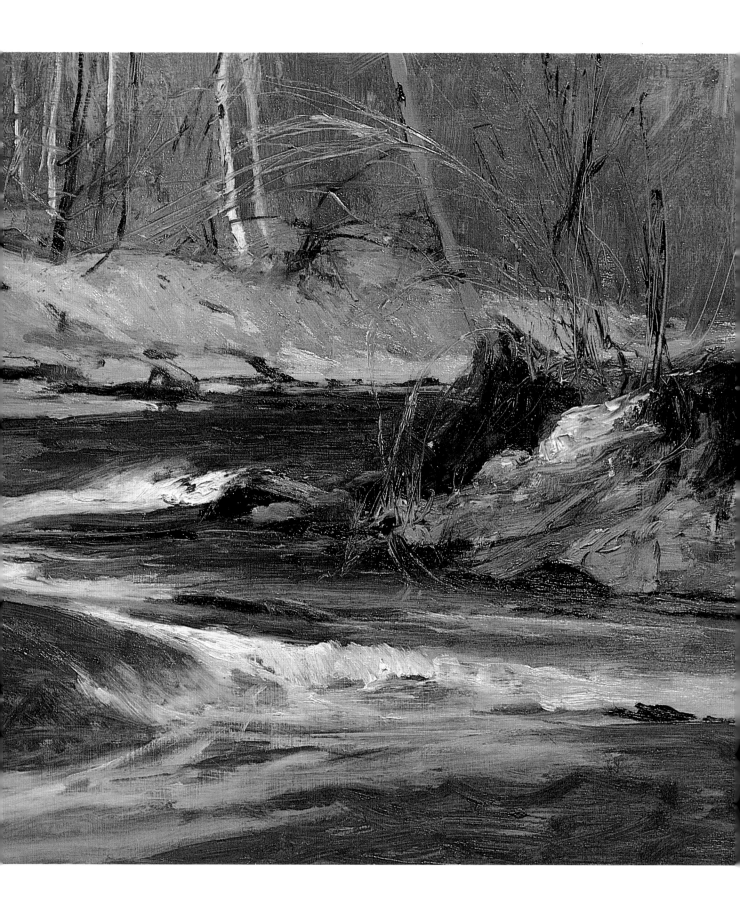

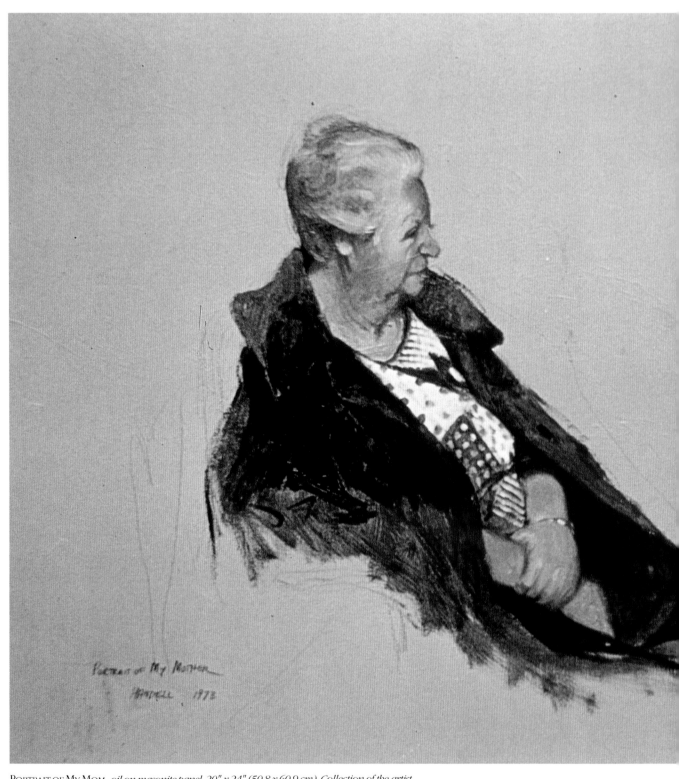

PORTRAIT OF MY MOM, *oil on masonite panel, 20" x 24" (50.8 x 60.9 cm). Collection of the artist.*

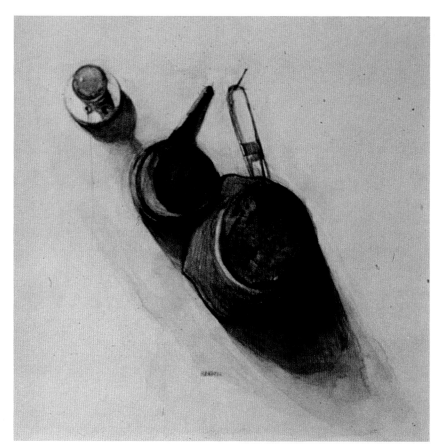

THE HANGING POTS, *watercolor, 14" x 12" (35.5 x 30.4 cm). Private collection.*

Above is a still life of some favorite pots of mine, hanging on my studio wall near a light fixture. The objects are diagonally hung on the wall. I laid out their placement in that way so that I could establish their relationships, paint their details, and keep the sense of the diagonal. The light source adds to the diagonal of the painting. Natural light enters from the upper left, causing the pots to cast strong diagonal shadows to the right. Since the objects are fixed to the wall, there is no perception of depth to this painting. The entire composition is based on the diagonal movement of the objects and their cast shadows. This simplicity and the diagonal thrusts carry the painting.

In the composition at left, my mother's portrait and the way she is seated was the only thing that interested me, and so I kept the painting a vignette. The entire vignette has the subtle thrust of a diagonal movement. You can follow this by mentally drawing an outline from the top of her head down the front of her portrait. Then follow her left shoulder and the coat overlapping her left arm. Take the outline of her coat to where it ends. You will note that these are clear, strong diagonal lines. The diagonal line is then repeated by the coat as it goes around my Mom's shoulders and down to where her hands rest in her lap. The linear diagonals that go around her shoulders are a perfect setting for the oval shape of her head and portrait. You might also notice how your eye goes downward diagonally from her portrait, the center of interest, to the suggestion of her blouse, and then to her hands. This movement actually makes the whole pose the center of interest.

## Curved and Circular Movement

The eye loves to follow curves and circles. A linear curve has a beginning and an end to it. A curved movement means that there is a curved line that the eye rides on or a number of unattached objects that would make up a curved movement if these objects were all visually tied together. The same is true with a circular movement. Basically, it is a group of objects that are separate but visually tie up to create a circle, an oval, or an ellipse. Circles, ovals, and ellipses are complete shapes. They are continuous and have no beginning or end to them.

Curved movement has a flow to it and can take many different shapes or directional movements in the composition. In compositions based on curved movements, the movements weave in and out of the picture plane and are rhythmical instead of static.

The picture plane is flat. If a feeling of depth is present, it is within a flat plane. The curved or circular movements can create the feeling of depth when they are tilted into the picture plane and thus put into perspective. Then they carry the eye in an elliptical movement in and out of the painting, giving perspective to the design.

Circular movements are unbroken and have a continuous flow to them. They are generally bold and pleasing to the senses. They rotate or swirl, breathing more energy into the composition, and help to maintain it within the picture plane. In circular movement, the eye returns over a course, following an endless chain. The eye gazes at the center of interest, moves to another area or object, then to another and another and eventually, as if going around in a circle, back to the center of interest, thus staying within the framework of the design. A circle symbolizes completeness, harmony, and unity, and when it is used prominently in a design, it can be the basis for a strong composition. The circle in a composition has great value in unifying and simplifying areas. When circular movement is used, it should maintain a delicate flow that balances the arrangement of objects or areas within the composition.

PORTRAIT OF JERRY SCHIFFER, *pastel on sanded board, 18" x 24" (45.7 x 60.9 cm). Collection of Mr. Jerry Schiffer.*

It was a cold day in Bucks County, Pennsylvania, when Jerry walked to my studio to sit for his portrait. He was the hearty outdoor type, and he arrived wearing a warm leather jacket with a heavy fur collar that wrapped around his head. The collar made a beautiful curved movement as it went from shoulder to shoulder, framing Jerry's face.

The circular framing of the collar brought out the roundness, the forms, and the features of Jerry's portrait beautifully. When dealing with the underlying form and anatomy of a portrait, one must be aware of the curved and circular movements of these underlying forms of anatomy. For example, there is a strong curved form to the roundness of Jerry's forehead, yet the forehead has lots of detail to it. The eyes, which are circular, can be considered as balls, eyeballs sitting in their surrounding sockets. A strong curved movement links the rounded shape of the mustache and the beard on his chin into the entire shape of Jerry's head, which is an oval. The curved and circular movements in this painting work on both a large scale in the design and a smaller scale in the actual anatomy of the portrait.

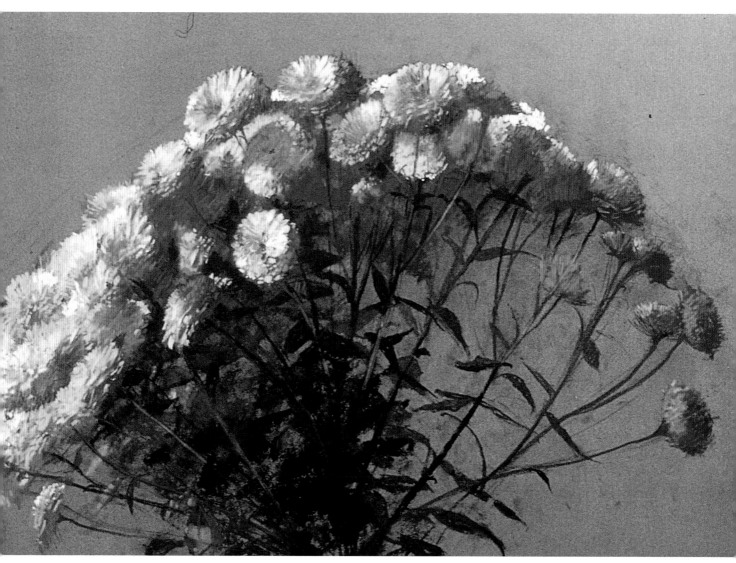

MUM'S #1, *pastel on sanded board, 16" x 22" (40.6 x 55.8 cm). Private collection.*

The eye will travel along the lines of a curved movement, especially if it is as clear as it is here. We are accustomed to reading from left to right, and we will also read the movement in a composition from left to right. The outline of the mums is a varied curved movement directed upward at a comparatively steep angle. The outline seems to rest in a straight line at the top before continuing downward on the right. This curved movement is repeated in the less obvious line beneath the mums. The space the mums occupy is wider on the left and narrower on the right. In the upper central section, I was able to create more circular fullness within the mums and their details. Each flower seen completely and not obstructed by a flower in front of it is circular. This movement is reinforced by the circular rhythms of the petals. Allow your eye to linger on the mums at the top, and you'll discover the way I used circular movement in painting the small flower groupings.

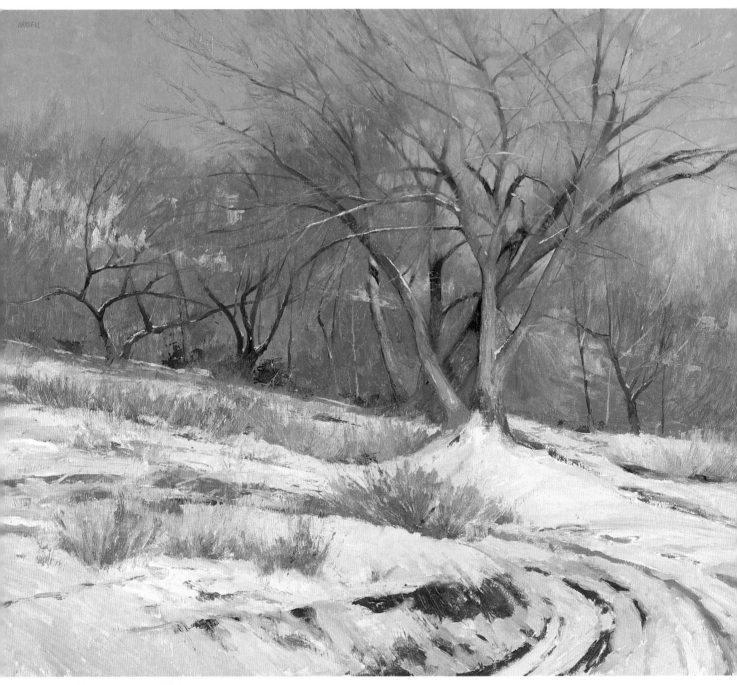

THE HIGH ROAD TO TAOS, *oil on masonite panel, 30" x 36" (76.2 x 91.4 cm). Courtesy of the artist.*

I came across this scene along the High Road to Taos, where I find many of my paintings. The main tree with all its movement and rhythms, changing colors and textures, was my major interest. The light on the tree is a soft light that clearly brings out these aspects. The surrounding trees are merely suggested as patterns with very few details so as not to compete with the details of the main tree. There are many varied curved rhythms in the tree itself, but compositionally, the most important curved rhythm is the one found in the foreground snow. Here, the curving, circular movement sweeps the eye directly into the composition to the center of interest. This movement is so strong that it allows me to play down other details in the foreground and concentrate on the details of the large tree and the surrounding background trees.

## Triangular Movement

Everyone knows what a triangle looks like. A triangular movement is when the eye travels from one area of the painting to another area in a triangular shape. When the base of the triangle or triangular movement is at the bottom of the composition, there is a great sense of security. When it is at the top of the composition, with the arrow of the triangle pointing downward, there is a great sense of peril, of instability or falling. It needs other elements in the composition to balance and stabilize it. Often, in this type of movement and composition, other triangular forms balance it in the strongest and most solid manner.

Triangular shapes or triangular movements can be placed centered or off-center in a composition. I like to place them off-center. When a triangular composition is used, the main shape is usually constructed of a large off-centered shape with smaller supporting triangular shapes or movements throughout the composition. Triangular composition is very obvious and its effect is very containing. It is a very stable movement in a composition. Each side of the triangle supports the other, creating its solidness and stability.

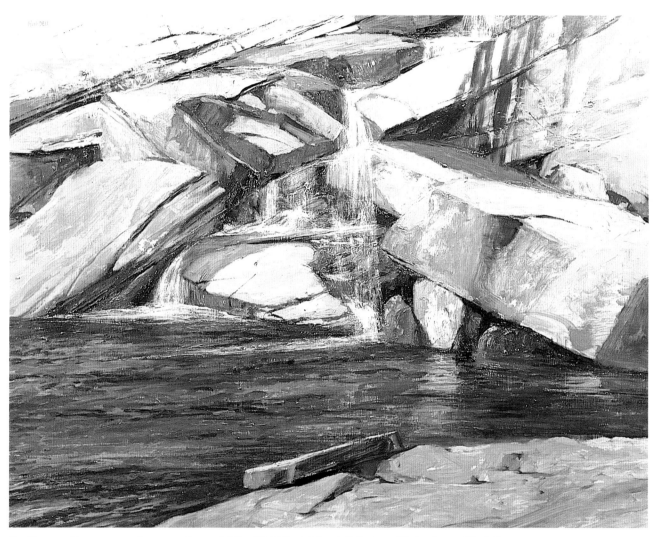

THE ROCKS AT KAATERSKILL, *oil on masonite panel, 24" x 30" (60.9 x 76.2 cm). Collection of Christopher and Linda Tors.*

Rocks are very difficult to paint because their shapes are elusive. They have to be organized into strong shapes to bring out their qualities, or they will forever be a problem as subject matter. It is important to convey a sense of weight when you are painting rocks. Triangles and triangular movements can work very well with rocks. For example, an upside-down triangle is a top-heavy shape. It can't be balanced forever. Triangles or rocks that take on triangular shapes in a painting contain weight and have to be braced or they will fall, very much the way rocks exist in nature.

In the *Rocks at Kaaterskill*, the central focus is on the braced group of rocks. There are triangular shapes on both the left and right sides that add tension to the central rocks. Directly under the large rock is a small upside-down triangular-shaped rock supporting the large rock above it. There is a feeling that the shape of that rock cannot hold up the large rock forever, and the weight of the rock will crush the weaker upside-down triangle. This creates a static movement for the moment, but the impending movement of crushing weight is clear. Other triangular movements weave in and out of the composition. Notice the sunlight at the upper right and the dark lines parallel to it, which reinforce the angle and represent dark cast shadows. All these lines seem to drive downward to the small triangular rock, increasing the sense of crushing weight.

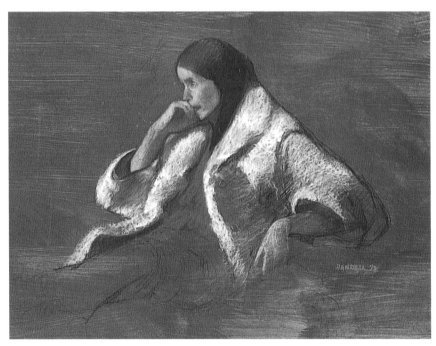

THE WHITE FUR COAT, *pastel on sanded board, 22" x 28" (55.8 x 71.1 cm). Private collection.*

*The White Fur Coat* (above) is a portrait pose, a painting in which the portrait and the position and attitude of the sitter become one. It's a very different type of portraiture from the familiar head and shoulder type portrait, where mainly the features are important. In fact, the features in this portrait are played down. The suggestion of them allows the viewer to look at the portrait pose as a whole. The background is a rich, transparent, texture of pastel diluted with turpentine. Triangular shapes are important in the drawing of the pose and in the placement of the pose on the paper. The portrait pose itself, comprising the positive areas of the painting, is basically a large triangle. Within this large triangle, many smaller triangles reverberate. The negative spaces of the unpainted background to the left and right of the figure also have triangular shapes to them. In this pastel, the eye moves from one triangular shape to another, as one enjoys the subject of the pastel.

I began the painting at right by sketching in the banana vendor and some of the objects that surrounded him and touched him. I then established more detail in the banana vendor himself and reinforced the strong upright shape he takes in the composition. I worked on the figure from top to bottom, adding clarity. Then from the front of the figure I established the sweep of the white tarpaulin that takes the eye to the left of the painting, the area in front of the figure. As I worked and developed the painting, I started to realize how many triangles were being established and how they interacted with one another. Throughout the painting, the triangles are both obvious and subtle, their shapes interplaying with the movement of the painting. The large triangular shapes are those that take in the banana vendor, the white tarpaulin, the large stack of bananas, and the triangle of sunlight on the ground in front of the vendor. Smaller triangular shapes can be found in the pile of bananas on the table behind the vendor, the red sweater of the seated woman on the left, and the entire shape of her figure.

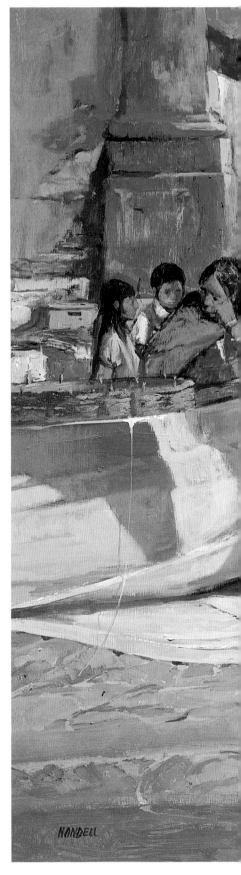

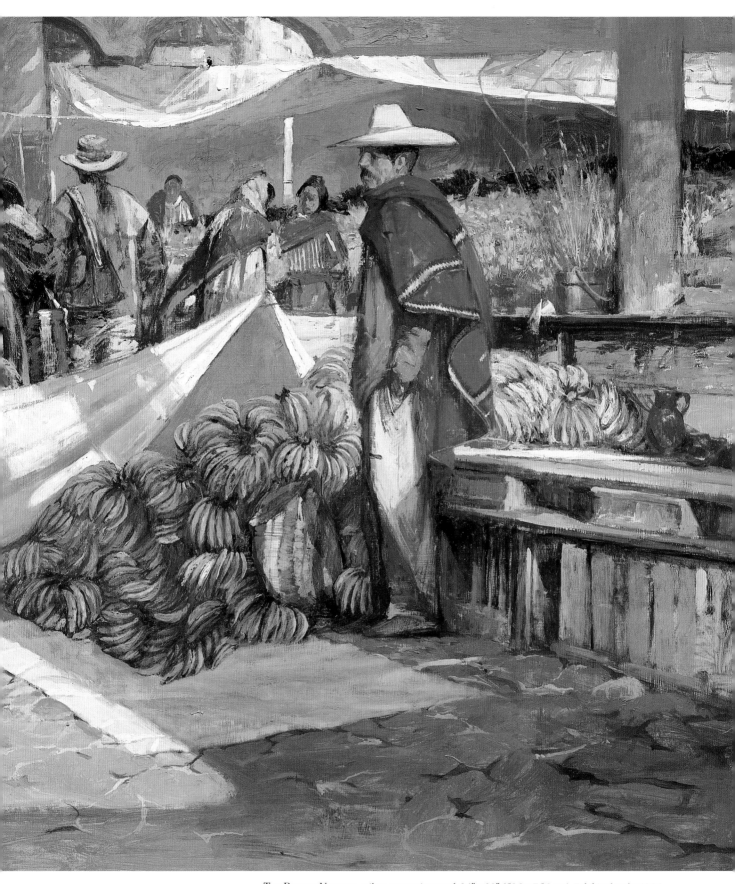

THE BANANA VENDOR, *oil on masonite panel, 24" x 30" (60.9 x 76.2 cm). Exhibited at the 1984 Denver Rotary Club's Artists of America Show. Collection of Mr. and Mrs. Russell Fleischman.*

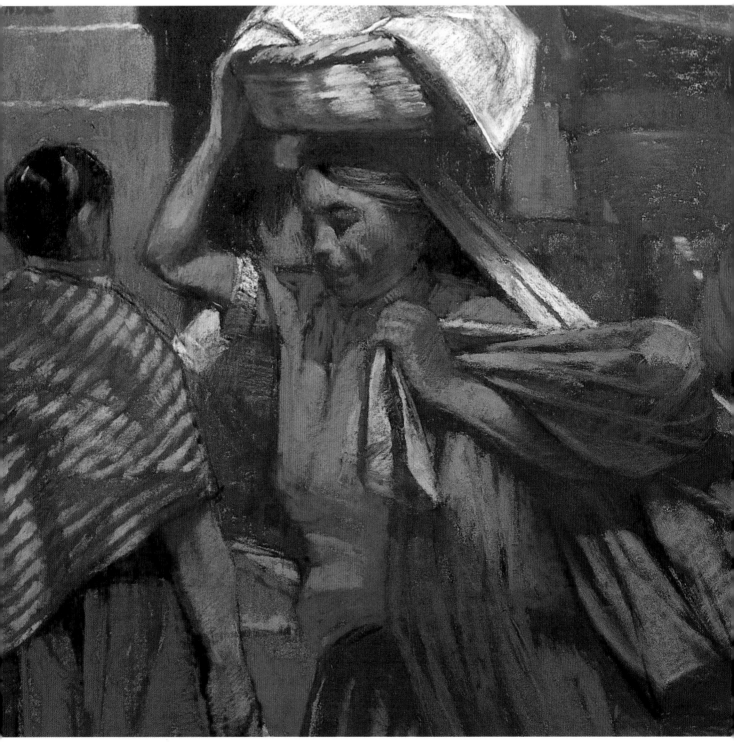

FRIDAY MARKET AT PATZCUARO, *pastel on sanded board, 11" x 16" (27.9 x 40.6 cm). Collection of Mr. and Mrs. Robert Kitchen.*

## *Opposed and Unopposed Angles*

Angles are made with two lines, usually straight lines, meeting at one point. For our purposes we will presume the lines that make up our angles are always basically straight.

There are different types of angles. In geometry, there are right angles, obtuse angles, acute angles. In designing paintings, there are opposed and unopposed angles.

There is an unopposed type of angle in which the lines of the angle are like a railroad track in perspective. They simply meet at a point and the eye is like a train riding the lines of that track, going straight into the painting to the point of the angle where both rails meet. This is an unopposed, fast-moving angle.

Opposed angles and combinations of opposed angles basically keep each other in check. There is generally more weight and more tension than speed to them. The opposed angles are worked into the design a bit like a tightly knit chess game, where things are balanced against one another.

Earlier we observed the effects of horizontal, vertical, and diagonal movements separately, as they create balance and thrusts within the compositional framework. Here we are looking more closely at how opposed angles, by themselves or in combination, can balance movements, be dynamic, and at times have an off-balancing effect. They can show stability or instability. They can be top-heavy, show falling weight, and can easily represent recession into pictorial space.

Use of opposed angles is essential to balancing the main directional thrust of the composition. Especially when a movement is following only one direction of the picture plane, it is necessary to balance it with an opposing movement or angle. Where the opposing angle crosses the main directional movement is usually a very important point in how the angle is incorporated into the composition as to what feeling of movement will be conveyed and how the eye will be directed.

In this pastel I worked intuitively, wanting to get the movement, the hustle and bustle that exists in the marketplaces. The movement is random, unsynchronized, unorchestrated—it could be just about anything except a collision course. The center of interest is the woman walking to the left, with her hand balancing a basket on her head. She is moving in a different direction from the man directly behind her, who is carrying a large sack over his shoulder. Observe these two figures and let them keep moving apart as they are. Soon you will sense a vacuum in the center of the composition. These angles are in movement. The angles and opposed angles found in this painting help create this movement. The opposed angles can be seen and felt throughout, giving the composition the tension it needs.

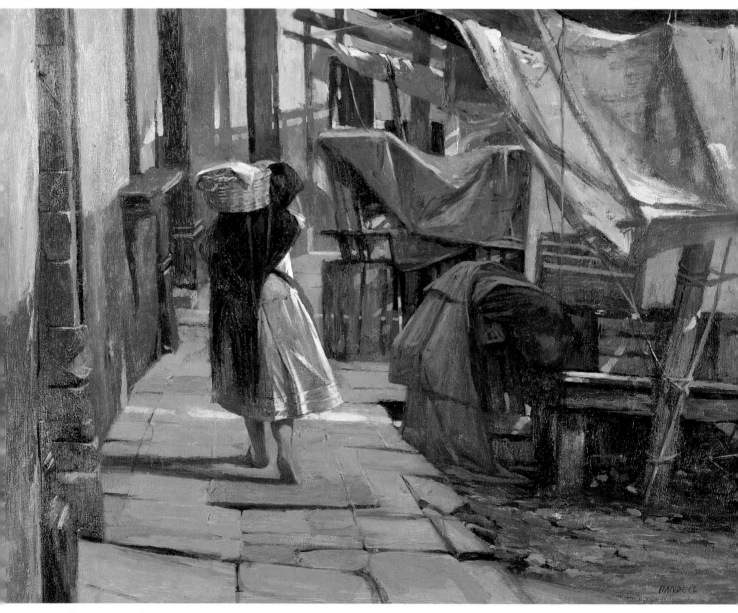

THE MARKET AT SAN MIGUEL DE ALLENDE, *oil on masonite panel, 20" x 24" (50.8 x 60.9 cm).*
*Exhibited at the 1983 Denver Rotary Club's Artists of America Show. Private collection.*

This painting could be an outdoor still life with shifting light. The shapes and their place-
ment and the opposing and repetitious angles were the important considerations in this
composition. Opposing angles, which can be used in many different types of designs, can
be orderly, giving a feeling of symmetry and tranquillity. In the example above, they give
the feeling of a lot of excitement through an orderly confusion. They beautifully help or-
ganize the haphazard scene behind the stalls of a crowded Mexican marketplace. On the
narrow street behind the marketplace all the vendors and stalls are facing to the right and
are not in view. The back view of the stalls is unpretentious; nothing is set up for display.
The area usually remains undisturbed until closing time. I wanted to get a sense of that
here.

## Symmetry and Asymmetry

Symmetrical composition can be the simplest and, because of this, the most difficult form of design. It gives a feeling of balance and stability, which is achieved by a centered division, usually a centered vertical, horizontal, or diagonal division of the picture plane, each half of the picture reversing or balancing the other.

Symmetrical composition is simple and straightforward to arrange. You know that if you place something in the center of the format, you balance each side of it with the same number or type of shapes, objects, or movements. The center of interest is usually very obvious. It is kept in place by the relative symmetry that surrounds it, and the eye does not travel unnecessarily throughout the painting.

A composition is usually not entirely symmetrical. The symmetrical element will predominate, but there will be subtle variety in the shapes and movements that mirror one another. For example, the composition may be divided in the center by a standing figure, but there will be differences in the outline of the figure. The difference in the outlines would create different negative shapes on the right and left sides.

Subtle asymmetry exists within symmetry: take, for example, the symmetry and asymmetry of a portrait looked upon full-front. There is an imaginary center line that divides the portrait symmetrically, with balancing forms on either side of it. These elements make the portrait symmetrical. But what interests me more is what makes the portrait asymmetrical. Are the two eyes really identical? Not really. There are subtle differences within all aspects of the portrait. One nostril may flare more than the other. One side of the mouth may be higher or lower than the other. And so on.

Asymmetrical composition means that both sides of the painting are balanced but different. In designing an asymmetrical composition, one has to keep in mind that there are many more options than in symmetrical composition, although balance remains an important factor. What is important in asymmetrical composition is that the elements are often more varied and complex than those found in symmetrical composition.

PORTRAIT OF BARBARA, *pastel on sanded board, 12" x 16" (30.4 x 40.6 cm). Collection of Tony Van Hasselt.*

Here is a clear example of a straight-on symmetrical portrait. Actually, the whole painting is very symmetrical. It is a small pastel, and the simplicity accruing from the symmetry gives this work its strength.

First, let's take the outline of the dark black hair. From left to right the line is long and upright, starting lower on the left edge of the surface than on the right. On the right, the outline of the hair has a different angle and starts slightly higher up on the right border of the painting. Also, its angle is different, and her head is placed a touch off-center to her right. The part in her hair is in the center, yet that too is slightly off-center and the part curves and is not straight. The hair surrounding the forehead leading up to the part is very different on the left and right sides. The right eye is also straighter than the left eye and doesn't have a sweep to it. The upper lip is slightly different from the left side to the right side, and the lines under the lower lip showing the top of the chin-line is certainly off-center and tilts to the right. The left ear is showing and the right ear is not.

MOTHER AND CHILD, *pastel and charcoal on sanded pastel board, 16" x 22" (40.6 x 55.8 cm). Collection of Janet Besso.*

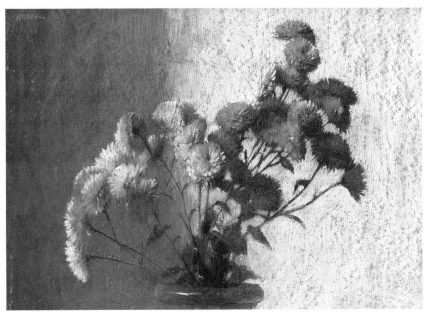

The Mums #2, *pastel on sanded board, 16" x 22" (40.6 x 55.8 cm). Collection of the artist.*

In the above composition, the symmetry is straightforward and gives the painting its simplicity. The mums and the background are divided practically in half. On the left, the mums are in light and the background is in shadow. On the right, the background is in light, and the mums take on a darker silhouette in front of this lighter background. This is kept simple. The painting is completed with strong emphasis on the entire shape of the mums and the painting of their details.

For the composition at left, I applied some pastel to a sanded pastel board and diluted the pastel with turpentine to produce the tone and texture for the background. I placed the figures of the mother and child far to the left, leaving lots of open space to the right. I knew all the human interest and details would be to the left of center with the mother and child, and I didn't want to crop the painting. If I did, the viewer would end up staring at the mother and child and the eye would have nowhere else to go. I wanted to leave extra space so that the viewer's peripheral vision could be satisfied enjoying the mother and child. Using very limited color and charcoal, I made a careful drawing of the mother, who acts as a frame for the sleeping child. The mother's shoulders and the seat of the child also make up a circular movement. I left the color primarily for the sleeping child's portrait, bringing the eye right to her and keeping it there. The extra space on the right is needed to balance out the asymmetry of this design.

NAMBE FARM, *oil on masonite panel, 20" x 24" (50.8 x 60.9 cm). Collection of Jon Thorson.*

Nambe, New Mexico, north of Santa Fe on the way to Taos, is still today a beautiful rural farming and ranching area. This painting shows only a small area of the farm, composed of a small, old yellow adobe building, no longer used; some old fencing to keep the cows in; and a random grouping of trees. The painting is divided practically in half by a strong upright, a tree nearly centered in the painting. It cuts the upper part of the painting in half. It also touches and combines with the yellow adobe building, which ties up the right half section of the composition. There is then a feeling that the right half section (the viewer's right) is cut in thirds by the roof lines and the line of the cast shadow on the yellow adobe wall. The tree in front of the building cuts the right side in half again. The entire area of the yellow adobe building—eliminating the ground plane below the base of the building and the purple area just above it—make up two squares almost equal in size. The symmetrical division in the right-hand part of this composition is made up of squares and linear divisions and has a boxlike feeling to it. As compared to the openness and spaciousness of the left side, the right side of the composition seems very geometrical. These sharp contrasts make this painting both symmetrical and asymmetrical.

# Part Three

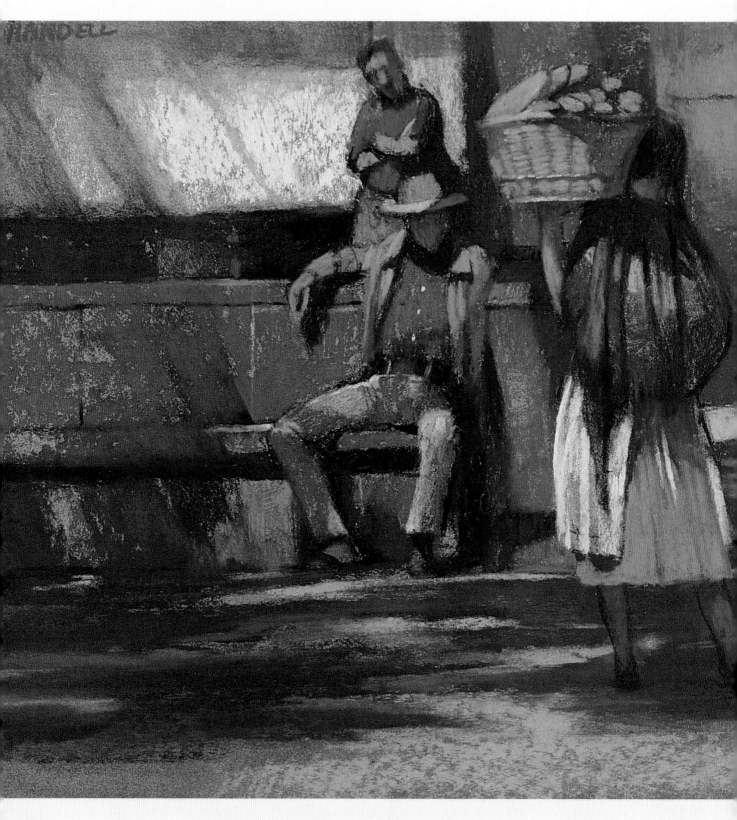

# TECHNICAL INFLUENCES ON COMPOSITION

*"When you go to art school you learn to draw and paint; you learn about rules in the process. For me, the general rule pertaining to rules goes as follows: If the rule helps you to see better, that's a good rule, keep it; if the rule keeps you from seeing, it's a bad rule, drop it."*

# Values and Masses in Composition

The value of a color is its degree of lightness or darkness. Every color, except black and white, has many shades. The lighter the color, the higher its value. The darker the color, the lower its value. When thinking in terms of values, every shade of a color is compared with a shade of gray on a scale of grays between white and black. To further understand the concept of color as value, picture a black-and-white photograph of a colorful scene, in which the myriad of colors that would normally be seen appear only as gradations of gray, with black as the darkest dark and white as the lightest light.

*Massing* refers to the unifying of all areas of a painting, separating areas that are similar or close in value from areas that are different in value, arranging them into simple shapes and large groups. Through this process, the abstract compositional shapes are defined and developed and much compositional strength and beauty is obtained. These simplified, colorful abstract shapes, understood by their values, subsequently have weight to them and are different from the shapes formed, for example, by a simple line drawing of a specific object.

The control of the values and their correct organization into masses is vital to the outcome of a composition. Balancing and interweaving light and dark value masses creates a sense of relatedness in the shapes of the composition. Light values in a composition reflect light, seem to expand, and come forward. On the other hand, dark values absorb light, seem to contract, and recede. The light value masses in a composition also seem to appear larger than the darker value masses even if they are the same size or shape. This effect results from their capacity to reflect and absorb light.

It is good to simplify values in a painting, and for practical purposes, artists limit the number of values they work with to approximately ten, ranging from white (1) to middle-tone gray to black (10). Of course, there are many more values in nature, but trying to capture them all would be as confusing, frustrating, and impossible as trying to duplicate nature itself. So organizing color into a limited number of values (light, middle, and dark) gives you a means of reducing a subject to simple artistic terms.

Understanding values and masses and their relationship to color is crucial to successful realistic painting and to the effectiveness of a composition. Without correct massing of values, the basic underlying structure of the composition will be weak, for it is the simplified masses that unify the composition, giving it its intrinsic strength and carrying power.

THE VIEW, SANTA FE, *oil on masonite panel, 36" x 40" (91.4 x 101.6 cm). Collection of Mr. and Mrs. John Stahr.*

In this composition, there are two well-massed areas that give the composition its intrinsic strength and carrying power. The values and colors of the earth plane are separate from the lighter values and colors of the sky. Basically, the sky is kept simple and stands as one large well-massed area. The same is true of the foreground on the ground plane. It is composed of a general overall yellow ocher color, with lighter, off-white colored snow patches and some slightly darker colors to vary and accent the suggestions of wet, melted snow and mud. The third area of the composition—the houses and trees in the distance—is the smallest area of the painting but has the most color and value contrasts to it.

Thus by using a few values, only three or four, and massing them into light, dark, or middle values, the most powerful effect in a composition can be created. The massing helps to identify the darkest darks and the lightest lights, eliminating the details and subtle nuances that would detract from and break up the carrying power of the underlying abstract structure of the composition. But most importantly, understanding and controlling the values and masses in this manner will allow you to build and develop your painting solidly from beginning to end. If a painting holds up well in black and white, in the massing of its darks and lights, has a strong middle-tone, and the value relationships are good, the outcome of the composition will therefore be strong and will be ever more successful in color.

Keep in mind that realistic painting attempts to project an illusion of reality. Integrated and harmonized values and masses along with all the other elements of the composition help to achieve the desired result of realism and illusion. As a painter is limited in his means of duplicating what he sees, limiting everything we see to a scale of values may seem at first a disadvantage and an impossibility. But it is just this limitation that is amazingly powerful and direct in achieving simplicity and a powerful illusion of reality.

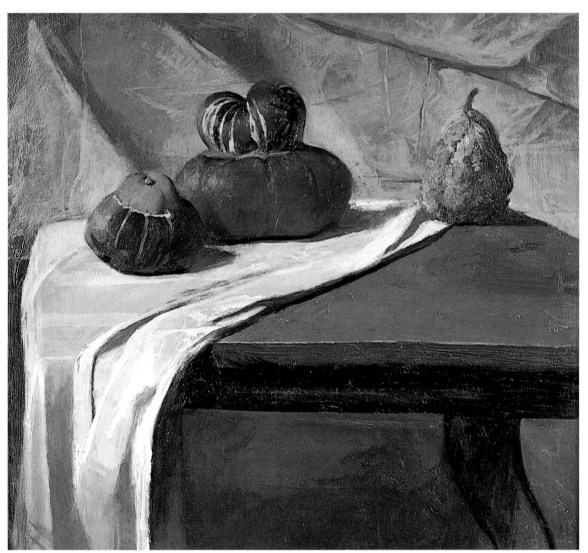

THE GOURDS, *oil on masonite panel, 22" x 24" (55.8 x 60.9 cm). Private collection.*

The three gourds are varied in texture and very rich in color as compared to all the muted tones of the painting. Working rich color and detail into them defines their shapes and allows them to come forward and dominate the center of interest. The values and colors of the table, the white cloth on the table, and the background drapery are alive with warm and cool grays. They are simply stated and well-massed.

The color of the top light greenish gray area of the gourd on the left is very close in value to the background grays. Thus, the light green and background grays are visually muted together. This similarity allows for a background/foreground relationship, whereas the other two gourds stand out strongly from the background because of their contrasting rich colors and striking value contrasts.

# Light and Shade

There is a directional aspect to light and shade, which is a very important element and at times can make or break a painting. I find that the general overall effect of the light and shade is what's important compositionally. When light and shade are perceived and incorporated correctly, there is a sense of harmonious movement throughout the entire composition.

To understand this concept, imagine the same subject being painted without changing your viewpoint but simply changing the light source. Distinctly different compositions would result. The different light sources would alter the way in which the shapes would be perceived, resulting in distinctly different patterns of masses and thus a distinctly different composition. For this reason, it is important to establish the pattern of light and shade in the beginning of a painting and to maintain its stability throughout.

## Rim Lighting

With rim lighting, sometimes called backlighting, the subject is in between the viewer and the light source. Strong silhouettes of all the upright objects are seen. Details are hard to see, but the shape of each object is obvious and the composition will have to show this clearly.

## Flat Light

When the opposite type of illumination is used—flat light—the light source is behind the artist, illuminating the scene directly in front of him. In this type of lighting, objects are seen in their entirety, with a minimum of shadow and a maximum of detail. When painting this type of lighting into a composition, especially in the case of outdoor sunlight, I find the light exciting but often too extreme. Compositionally, I add some contrast, usually a strong cast shadow that falls on the bottom third of the canvas. The darker, cooler colors of the shadow mass contrast with the warm colors of the flat light, adding interest to the composition

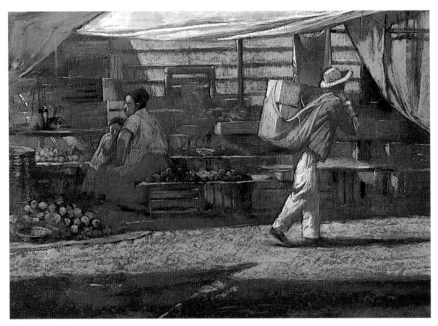

MARKET REST, *pastel on sanded board, 16" x 22" (40.6 x 55.8 cm). Collection of Max and Lee Salomon.*

*Market Rest* is an example of the dramatic effect of an object in half light and half shadow. The man in the foreground with his white pants and several heavy boxes in a sling over his shoulder is in a strong half light. His figure throws a strong cast shadow. This contrasts with the mother and child with their array of market goods, which are in a penumbra, a cast shadow thrown from the overhead awning. Although this cast shadow area is a darker area of the painting, it is still a luminous area, and the play of light, shade, and details found there can be enjoyed. Also, note the shapes of the light and shadow made by the strong cast shadow in the foreground. Compositionally, this strong cast shadow, with its darker, cooler colors, forms an interesting shape that contrasts with the shapes of the warm, sunlit areas. In this composition, it is not just the objects that are of interest but also the play of the strong light and shadow and the patterns they make.

## Half Light

In half light, the light source is either to the left or to the right of the artist. The artist views what's being seen in half light and half shadow. It is a dramatic light, which because of the strong patterns of light and shade, cuts the objects and competes with the details. This is tricky since we normally can see into light areas more easily, seeing more variety and details in the lights, whereas shadows are more diffused and can be seen more readily as shapes and patterns. This combination of shapes and details makes for very special types of compositions.

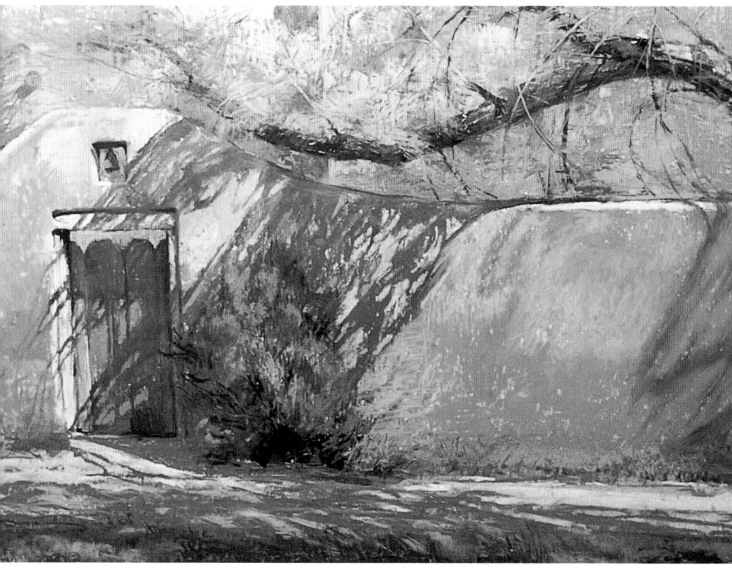

SUN-WASHED PORTAL, *pastel on sanded board, 16" x 22" (40.6 x 55.8 cm). Private collection.*

The subject in this pastel, which has an overhead flat light illuminating it, is a good example of the importance of cast shadows. Compositionally, cast shadows show many things—for example, how close or how far objects are from one another and which direction the light is coming from. They also give a sense of weight. In this pastel, the shadows indicate that the light is from above and to the right. The darker cast shadows in the center of the portal also show how close the tree is to the door. These cast shadows are strong. They are darker and have crisp delineated lines to them, and their shape is clearer. To the far right falls a very soft cast shadow thrown by something farther away and not even in the painting. This cast shadow is lighter, has very soft edges to it, and gives a feeling of added space and breadth beyond the borders of the painting's edges. The play of these cast shadows, which are an intrinsic part of the light and shadow, certainly can add depth and reality to a composition.

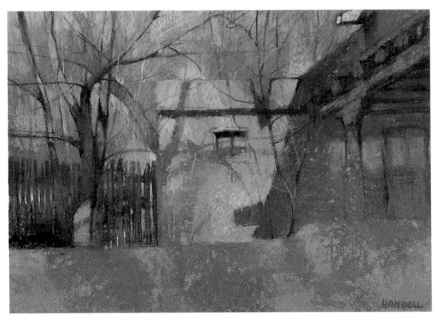

DELGADO ADOBE, *pastel, 10½" x 15" (26.6 x 38.1 cm). Courtesy of the Ventana Gallery, Santa Fe, New Mexico*

The afternoon light in Santa Fe is truly beautiful and unique; I have never seen the likes of it anywhere else. In these two paintings it's the play of the light as it cuts across the composition diagonally above and horizontally at right that gives the drama to the painting, and helps anchor the complex design.

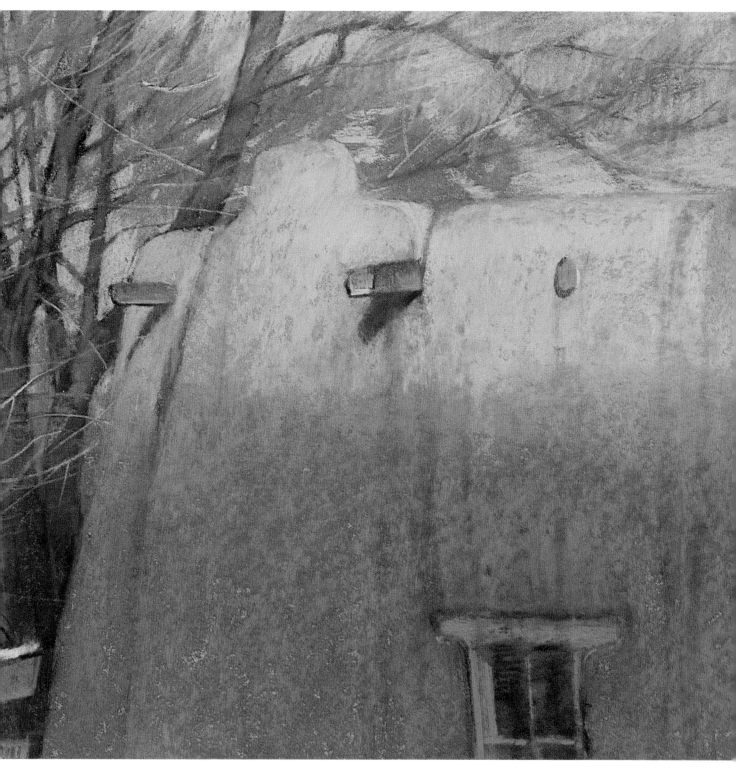

THE LIGHT, *pastel, 11" x 16" (27.9 x 40.6 cm). Private collection.*

# Color in Composition

Color is energy. The use of energetic, beautiful color in painting is truly an art, for color affects us emotionally. Seeing color is a very deep, personal, and individual experience. Some of us see a lot of color everywhere, whereas others pass through life mostly unaware of it. Many painters are born with a gift for seeing color; others can acquire the ability through studied awareness.

Our reaction to color is not only personal but spontaneous, and its most successful use in composition is when we trust in and follow our personal responses and intuitions. However, an understanding of the basics of color and how colors interact and affect one another is needed to successfully develop a sense of color for composition.

## The Basics of Color

Primary colors are basic colors that cannot be mixed from any other colors; they simply exist. The primary colors are red, yellow, and blue.

Secondary colors are formed by mixing any two of the primary colors together. The results are

Red + Blue = Purple
Red + Yellow = Orange
Yellow + Blue = Green

A complementary color is the primary color not used for the mixture of any secondary color (green, purple, or orange). For example, orange is mixed from yellow and red. The primary color missing in this mixture is blue, so blue is the complementary color of orange. Using this simple method of deduction,

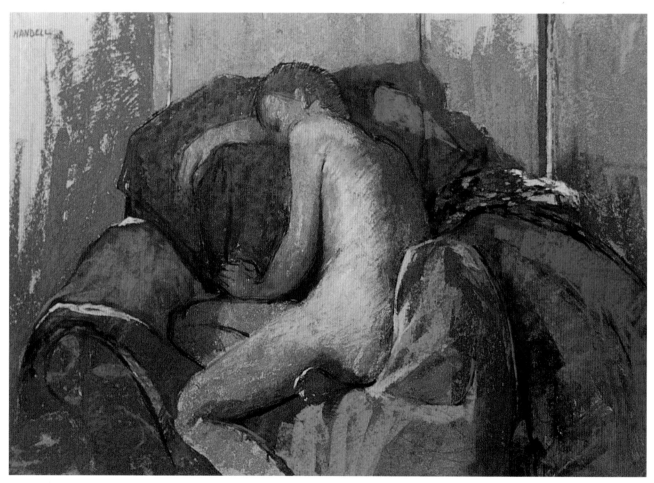

ASLEEP, *pastel on sanded board, 16" x 22" (40.6 x 55.8 cm). Private collection.*

The use of different colors of similar values applied alongside one another or blended together binds the basic shapes of the underlying structure of the composition. At the same time, it allows for a tremendous variety of color. In the pastel *Asleep*, the entire nude figure is made up of many rich colors, yet the values of these colors are close. The lightest values and the brightest colors are in the flesh tones of the body, which catches the most light. The flesh tones then go through a transition, for the colors of the legs, arms, and head are slightly darker. The surrounding colors add contrast to the flesh tones. The screen on the left is a muted purple in color. This muted purple is the same value as the richer, redder, purple cloth on the armchair. Where these two colors touch, the edges between them practically disappear because the values are very close and the eye easily moves from the foreground into the background. Harmonizing color through this concept of massing colors of similar value creates a solid compositional structure.

find the complements of purple and green.

Tertiary colors are produced by mixing all three primary colors together or complementary colors together. For example, by mixing red (a primary color) and green (a secondary color and also the complement of red), we get one shade of brown. Another example would be to mix yellow (a primary color) with purple (a secondary color and the complement of yellow). This would result in still another brown or tan. Tertiary colors are extensive and basically comprise all the browns that exist.

## Color Breakdown

Each color has three aspects to it: hue, or local color; value; and intensity. *Hue* is just another word for the local color of an object, that is, the actual color of an object, such as a "red" hat.

*Value*, as explained earlier in the section on values and masses in composition, refers to translating the color into its degree of lightness or darkness on a scale of grays ranging from white to black.

*Intensity* refers to color at its purest and brightest state, for example a bright yellow. If you were to take this yellow and mix it with a gray at the exact same value, its intensity would be lessened, but its value and hue would remain the same. This would be true of any color mixed with a gray of the same value.

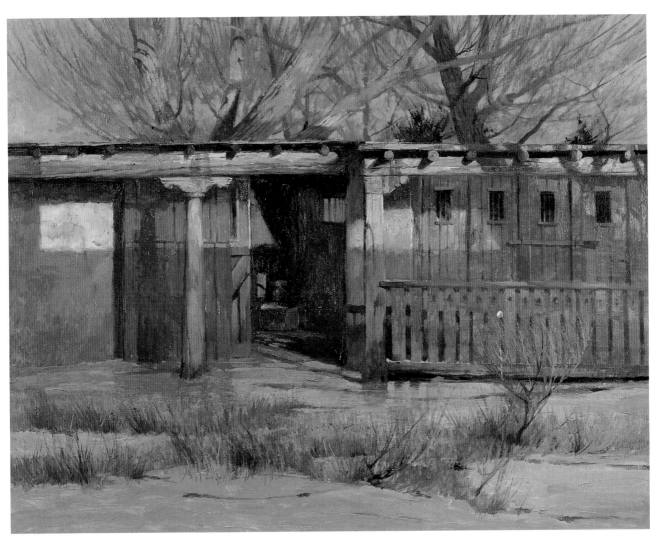

ICING OVER, *oil on masonite panel, 24" x 30" (60.9 x 76.2 cm). Collection of Robert M. Pettus.*

The strong use of complementary colors can be an important element in the design of a composition, as the winter light of late afternoon in *Icing Over* clearly demonstrates. At this time of day, the sun is low in the sky and its yellow-orange light glows. The shadows are strong with a bluish purple color to them. In my painting I wanted to obtain this play of yellow orange and purple. Thus, I used the purple as a base for the background sky. It worked beautifully as a cool background color for all the complementary warm colors in the foreground tree and adobe. In the foreground cast shadow area, tones of purple were subtly echoed in all the colors. This unified the painting and added more vibrancy to the foreground warm colors. Yellow and orange were mixed into all the colors in the sunlit areas, and in some specific areas dabs of yellow and orange were dramatically applied. A special quality of color resulted.

## Warm and Cool Colors

All colors basically fall into either a warm or cool category. Essentially, warm colors are yellows, oranges, reds, reddish purples, warm browns, and warm grays. Essentially, cool colors are bluish purples, blues, greens, cool browns, and cool grays. Naturally, within these categories, there is room for many subdivisions. For example, in a comparison of greens, there are warm greens, cool greens, and neutral greens (those in between).

Since two primary colors—yellow and red—are warm, and only one, blue, is cool, most color mixtures seem to fall into the warm category. A danger in some realistic painting is that a convincing, realistic painting can be established just using the warmer color mixtures of the palette. Without knowing it, a brownish overly warm painting can result. Compositionally, I feel colors should constantly be balanced by warm or cool as the painting proceeds. This can be achieved through a sensitivity to warm and cool colors and through the use of complementary colors.

## How Color Affects Composition

Traditional academic training in realistic painting stresses that color should be considered secondary at the beginning of a painting and is often played down or put aside until the structure is suggested and the value relationships are clearly established. Color is then worked up as the forms of the painting are developed. This is a tonal attitude toward color and can and does work with desirable results.

Another approach is to compose in color, making rich use of color from the initial stages of the layout. It is thrilling to lay out a painting in transparent color washes on a white background. The colors are vibrant and sing out in a special way. However, care needs to be taken to keep the colors harmonized.

The colors of a composition are affected by the color of the surface being worked on, by whether it is a pre-toned ground or a white ground. When working on a pre-toned middle-value ground, the colors are immediately in harmony but tend to be duller than when working on a white ground. Also, transparent colors don't seem to be as vibrantly transparent when applied on a pre-toned ground as when they are applied to a white ground.

Color has a unique spatial action to it. Cool colors recede, and warm colors come forward creating three-dimensional movement in a composition. This is an important way to manipulate color in composition. For example, a warm, intense, light-value color will vibrate and advance forward. But if you place a light, cool color of the same value next to it, the cool color will look darker and heavier than the light-value color and will also seem to recede. Of course, since the values of both colors are the same, a black-and-white photograph should reveal them to be two patches of the same gray tone. This proves that some effects produced by color are due to a difference in color temperature rather than a difference in value.

I have found that the play of warm and cool colors can also have a special "two-dimensional" effect, which in turn can affect the composition. I feel that

Compositionally, warm and cool colors need to be constantly balanced as a painting proceeds. This can be achieved through sensitivity to the colors as they are applied. In *The Coyote Fence, Santa Fe,* warm and cool colors were used in a direct and forceful manner in designing the shapes of the composition. Everything in shadow is not only darker but also cooler than everything in light. Cool tones were mixed into each color for the shadow, and warm yellows or oranges were applied to all the colors in sunlight. This helped elicit underlying patterns without relying on striking value contrasts. The warmth in the lights and coolness in the shadows prevail throughout the composition. To achieve a sense of luminosity, colors were brushed on broadly and values were kept high enough to make the colors glow.

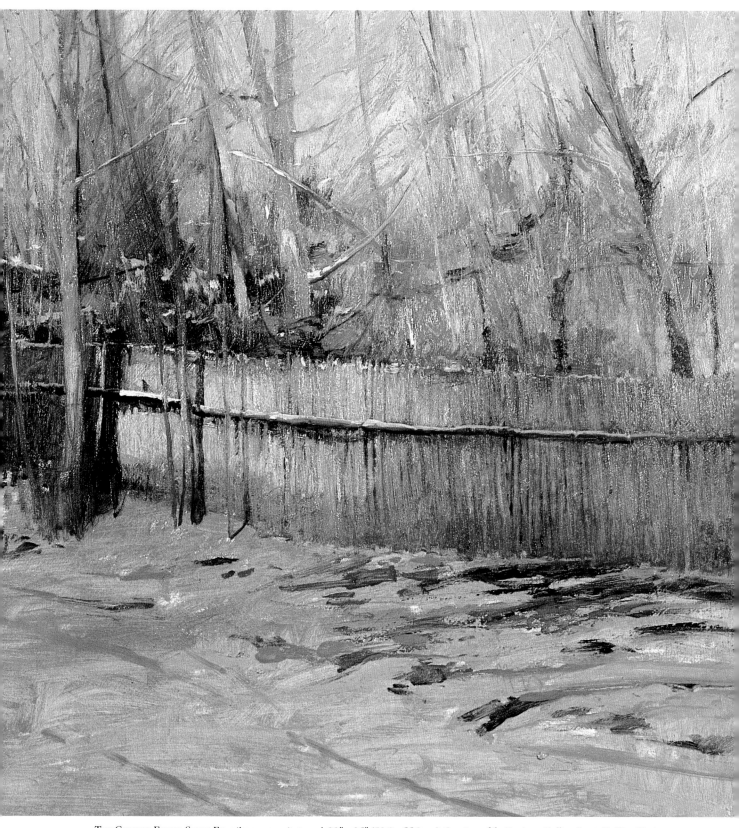

THE COYOTE FENCE, SANTA FE, *oil on masonite panel, 20" x 26" (50.8 x 66.0 cm). Courtesy of the Ventana Gallery, Santa Fe, New Mexico.*

THE BLUE REBOZO, *pastel on sanded board, 16" x 22" (40.6 x 55.8 cm). Private collection.*

cool colors have more weight to them and have a tendency to move "downward." Warmer colors are lighter in weight and have a tendency to "rise." It is similar to the way hot and cold air acts.

This perhaps is a new thought, a new thought that I have experimented with extensively. In my painting workshops, while demonstrating color theory with pastels, I began taking two complementary colors, one warm and one cool, both very, very close if not exactly alike in value. I made one-inch-square color patches of these colors, placing them to the left and right of each other on a light sheet of paper. On the left, the warm color was placed on the bottom and the cool color was placed on the top. They harmonized beautifully together. They seemed close in value and the edge that separated them practically vanished. Then on the right side, I reversed this and put the cool color on the bottom and warm color on top. These same two colors felt as though they were separating from each other, and their edge was obvious to the eye. I tried this experiment many times with many different tones of complementary colors. It always resulted in this manner. I therefore concluded that warm colors not only come forward, but on a flat "two-dimensional" plane also "rise"; and cool colors not only recede but, on the same flat plane, wish to "drop."

## Varying Color and Simplifying Shapes

Along with the effects the use of warm and cool colors have in composition is the consideration of color as value and the use of different colors of the same or similar values applied alongside one another or blended together in the masses in order to keep the basic underlying structure in place.

In order to maintain simple values and strong compositional shapes, realize the general value of the shape and vary the colors within it with different colors. Remember to keep the *values* of these different colors *close*. In this way, you won't have to blend your colors with a brush, since your eye will optically do this for you. This process can be expanded into broken color in which whole areas are harmonized, and then some strong, or at times dull, thickly applied color can optically sit on top of these areas with harmonized yet sparkling vitality.

I recommend much experimentation with color and its effects in compositions. Once you have learned the basics and are developing your own works, you will find that your idiosyncrasies, your preferences, your shapes, your color combinations will emerge. Be receptive to your intuition, and follow your instincts, your style, and your vision so that your personal sense of color will prevail.

Whenever I think of Mexican marketplaces, I especially think of rich color and the strong play of light and shadow patterns. In *The Blue Rebozo,* I designed the composition with both of these aspects in mind, designing the shapes as masses composed of rich color and contrasting values. The shadows were cool, and I kept them as transparent as the pastel medium would allow. Very rich colors were reserved for the clothing and the light area of the drop cloths. The abstract design of these shapes was so simplified that I used detail in the steps and the partially exposed column to catch the viewer's eye and keep it at the center of interest, which is the woman wrapped in the blue rebozo. As you gaze at the center of interest, you can sense the rich peripheral colors surrounding her, the sense of place.

# Lost and Found Edges

Lost and found edges are an intrinsic part of any realistic painting that possesses that magic quality of atmosphere. Essentially, an edge is the place where two areas of a composition meet or where a plane turns. Sharp edges can be easily seen. These are the edges the eyes move to directly. Sharp edges bring out the outlines of objects and show contrasts in the composition. In order to give more strength to hard edges, it's good to have lots of soft edges to contrast with them. Paintings are made up of contrasts and similarities. The more soft edges there are surrounding or underneath the sharp edges, the sharper those edges will seem and the less effort will be required to paint the look of them.

Sharp edges contrast with soft muted edges, and it is the soft edges that add air and atmosphere to a composition. Soft edges recede into the background, underlie or surround the sharp edges, or they just softly fall away.

The use of soft edges is most obvious in landscape paintings, where lots of distance and aerial perspective is part of the composition. They are more subtly used in portraiture and in still life paintings, with no distance or aerial perspective to them.

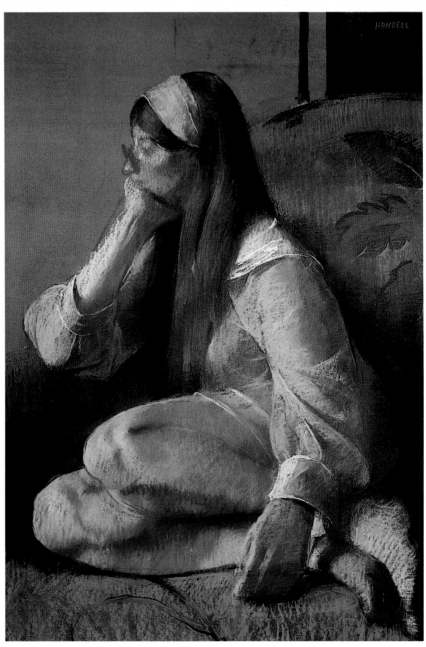

PROFILE OF SUSAN, *pastel on sanded board, 18" x 24" (45.7 x 60.9 cm). Collection of Dr. and Mrs. Joseph Gardocki.*

The lost and found edges in this pastel are subtle, since the subject is in the foreground and there is no need to show vast distances in this painting. Susan is leaning on her right arm, her right hand supporting her head. There are subtle lost edges between hand and head so that her portrait and right arm flow together and relate very emphatically. Also, the underlying value of the shadow area of her left arm is the same as the chemise that is behind her left arm. As a result, the underlying edges between her left arm and her back are lost edges. On top of this muted simplified area are some crisp found edges that bring out the arm and hide the underlying lost edges. Also, use is made of subtle, soft, lost edges that visually unify her two legs into one large shape. At first, the soft edges do not catch the viewer's eye and we sense details that we just presume are all over the composition but simply aren't.

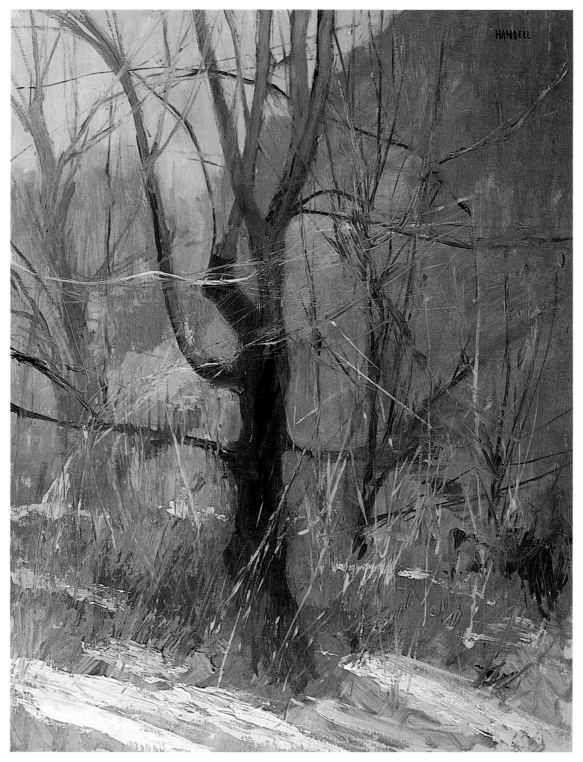

TREES IN WINTER, *oil on masonite panel, 16" x 22" (40.6 x 55.8 cm). Private collection.*

To capture a sense of distance in this painting, I kept the yellow ocherish foreground color and the purplish gray color of the background close in value. The edges where these two colors meet are hard to find. They are so blurred, in fact, that the two colors seem to drift in and out of each other. This allows the foreground to recede into the background quite easily. The outlines of the foreground trees then stand out against these soft, lost, muted edges. Had I not lost the edges in this painting as I did, I would have had to use sharper lines to outline the trees, and the whole painting would have lost the soft atmospheric quality I was after.

# Detail and the Art of Selective Finishing

We all seem to love detail. There is a fascination with it, and it's a very tempting aspect of realistic painting. Details have a lot of beauty to them, and it is the visual impact of details that gives us the strong sense of reality that impresses us in realistic painting.

Details appear on the surface and are easily seen. There are no underlying details that exist with the underlying masses. However, details alone without the underlying massing that constitutes strong composition can lead to uninteresting realistic painting.

How and where to put detail into a painting is a delicate selective process, an art in itself. A more traditional approach to detail, especially in landscape painting, is to put more detail in the foreground, less detail in the middle ground, and let the distant plane fade

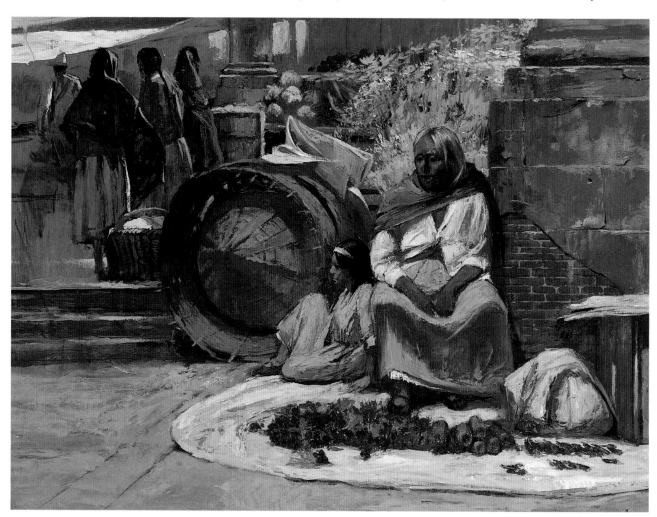

GRANDMA'S HELPER, *oil on masonite panel, 18" x 23½" (45.7 x 59.6 cm). Courtesy of Daniel J. O'Friel and Monika Steinhoff.*

The graduating emphasis of the painted detail here is interwoven into the composition. The wall on the right is the most detailed area of the painting, complete with nail holes, chipped plaster, and varied textures. Grandma and her helper, along with the large standing bread basket, have less detail, and they merge into the entire scene. The large bread basket is made up of a mixed combina-tion of patterns of light and shade plus some details. In the rest of the painting—the flowers, the background, the figures in the back-ground, and the large interior marketplace—there is much less de-tail and more patterns of values and colors. This losing of details as objects recede into the background adds variety to the composition.

away with even less detail, using lighter and grayer color. This will help achieve a sense of the third dimension, and it makes for a clear, simple composition. Realistic painters squint their eyes often while working to see if they have been successful in omitting unimportant details and to check the shapes and massing of the underlying composition.

I prefer to think of the details of a painting in terms of selective details. Aesthetic problems can easily result if all the details are painted to the same degree of finish or if too many are included. I try to avoid having the entire painting be equally detailed.

My inclination is to orchestrate the painting by varying the details and the design of the composition. Details must relate to the masses and to the composition of the painting, with some details being finished and others let go. If a painting becomes overloaded with too much detail, squint at what you are looking at. Then details will be harder to see, actually becoming lost in the massing. It's like returning to "start" again. You can remass and simplify the masses. Open your eyes to see the details and again try to finish areas, weaving the details in and out of the design of the composition, selectively finishing them. This approach will help bring more magic, more atmosphere, and more volume to the reality of the painting.

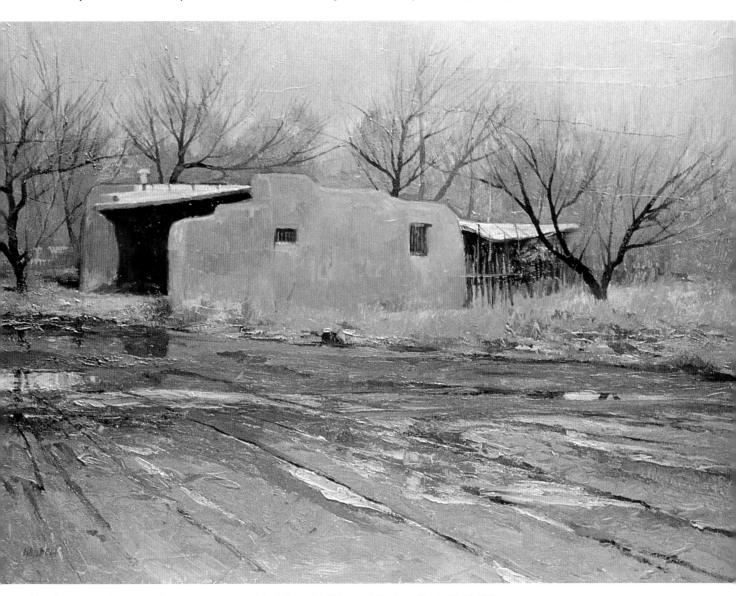

THE OLD ADOBE, SANTA FE, *oil on masonite panel, 20" x 24" (50.8 x 60.9 cm). Collection of Irwin Gadol, Ph.D.*

The atmospheric conditions of an early spring day after a heavy rain was the object of this painting. The foreground, which comprises the entire lower half of the painting, is spiritedly painted with lots of thick brushwork and a palette knife. I wanted to suggest wetness, reflections, and mud, but I didn't want the viewer's eye to linger there. Also, I wanted this broad paint quality to contrast with the delicate work of the old adobe and the selective details of the surrounding trees, which I painted last. Delicate colors with blurred edges had to be painted underneath the trees before the details could be painted on top of them. Compositionally, the yellow ocher color mixture that represents ground growth divides the composition in two.

# Texture

Texture is related to the painting surface. It is varied and beautiful and needs to be treated and understood as another aspect of composition. Depending on the surface qualities, texture can be touched and felt; it adds variety to realism. Before the work is begun, surfaces themselves can be chosen for their textures—rough, smooth, even, uneven. A wide range of textured surfaces is available. For oil painting, a few of the most commonly used surfaces are canvas with its textured weave, smooth wood panels, or rough burlap. In pastel painting, there is canvas for pastel; rough or smooth sandpapers, which have an even texture to them; rough and smooth irregular marble dust boards; and the delicate textures of the canson papers. In the watercolor medium, there is an entire assortment of rough and smooth watercolor papers to choose from. These are actual surfaces that give the visual equivalent of tactile sensations.

Textural differences of the various painting mediums—oils, pastels, watercolors—can also affect the look or feel of a painting and, thus, the basic composition. All have endless textural possibilities. They are visually different and delightful and relate differently to the textural surfaces they are applied to.

Another factor that can affect the textures of a painting is whether the artist paints wet or dry, or combines both techniques. In wet painting, with its meaty, blending properties, paint is usually applied thickly. Dry painting, on the other hand, produces more of a matte quality.

The combination of the textural effects of the various painting mediums, the painting surface, the textured qualities of the different objects in the painting, all have their effect on the outcome of the composition. It must be remembered that textures need to be kept in balance in relationship to all the shapes, tones, colors, lines, and details of the composition. Obvious textures that dominate in the composition will create patterns that, in turn, create shapes. Flat, smooth, varied, or rough textured patterns can give a feeling of texture much as designs in a fabric do. Some textures come forward; some recede. A rough texture in the foreground and a smooth texture in the background can create a sense of depth in the composition. Rougher texture adds depth to the shapes. Smoother texture gives a flatness unless there's a lot of rough texture with smooth blending for three-dimensional effect.

SEATED FEMALE NUDE, *oil on masonite panel, 20" x 24" (50.8 x 60.9 cm). Collection of Ginger and Chris Morris, Woodstock, New York.*

The example of texture in the composition above is painted on an even, opaque, middle-value gray-toned ground. The gray of the ground is not varied; it is very even and opaque from edge to edge and has a matte quality to it that serves well as a background. I began this painting by working transparently from the center of interest outward. I like to think of this process as a drawing of the objects and of compositional relationships all done with transparent colors. I like the textured effect these transparent colors have on the opaque gray ground. There's a looseness to the strokes that adds to the textural feel. In this painting, I also wanted to depict the textures of the two-toned leather chair. All of these elements, contrasted with the texture of the skin tones and the varied application of paint of the surrounding objects, help create the rich textures of this composition.

This interestingly textured painting of cottonwood trees lining a dried-up creek bed, captures a certain time in late winter or early spring when the small lacy branches of the cottonwoods turn from a light gray to a warm pale yellow color. In the afternoon, when the sky tends to cloud up, a very dramatic purple background appears behind the soft lacy branches. To contrast with this blended soft texture, I added the rougher textures of the dried-up creek bed in the lower foreground. I simply suggest detail, using texture as a means to this end. I started the foreground area with a richly textured transparent application of thinned-out color, a mixture of raw sienna with a touch of cobalt blue and yellow ocher. On top of this, I used color mixtures of opaque paint that were mixed to the same value as the transparent underpainting. I applied the paint vigorously with a palette knife, changing the texture, which gave a feeling of random growth. Added to this were some grays that contrasted in color with the warm earth colors. These grays were also rich patches of textured paint. The contrasting opaque and transparent paints clearly brought out the distinction between the foreground and contrasting background areas.

# Luminosity, Weight, and Atmosphere

Three important aesthetic elements that I always wish to achieve in my paintings are luminosity, weight, and atmosphere. I like to have a sense of all three elements in my compositions, combined with the reality of what I'm painting. For me, these elements are what create the underlying beauty of realistic painting.

Luminosity for me means a sense of light, of a prevailing light bathing and illuminating all objects in the painting. At times, details of less important objects are given up in a composition in order to achieve more simplicity and more overall luminosity.

In my traditional training, weight in the painting meant the solid three-dimensional form of all the objects painted. Objects were composed and set up so that their solid three-dimensional forms—with front and side planes and top or bottom planes—were easily discernible. Light was manipulated to emphasize this three-dimensional aspect. But weight in a composition has come to have a more all-encompassing quality for me. The entire composition has to have a general sense of weight, so to speak. Many a time I like to work on subject matter that is seen straight on with no side planes. Or I work only with the profile (side plane). I try to obtain my sense of weight through the size of the object and its placement on the surface, and I design my composition with that in mind, using light in the painting to add to the general weight in the composition.

A feeling of atmosphere is a sense of air or space throughout the painting. This is a subtle aspect of realistic painting and is much desired. It gives relief to the painted objects in the composition. When our eyes go automatically to the objects of the painting we are familiar with, we want to feel a sense of space behind, around, and in front of these painted objects. This feeling adds to the three-dimensional quality of the composition of the painting. Luminosity is essential in achieving this sense of atmosphere. Once there is a sense of overall light, a feeling of space, of air, and of atmosphere can be created in the composition.

AFTERNOON LIGHT IN ABIQUIU, *oil on masonite panel, 16" x 20" (40.6 x 50.8 cm). Collection of Robert M. Pettus.*

The Red Rock area of Abiquiu, New Mexico, is an extensive formation. In some areas, the rock is very red; in others, it is a reddish color intermixed with strata of yellow rock. These colors make up dazzling, luminous displays of color that take on a particular beauty especially when bathed by afternoon sunlight. I started this painting on location and finished it in my studio. While on location, I worked for a higher key and more intense color because later, in the studio, I intended to put glazes onto large areas of this painting. The quality of the glazed colors helped capture the special luminous effects of this painting. While the glazes were still wet, I worked with mixtures of opaque and semiopaque color in selected areas to unify the luminous aspect throughout the entire composition.

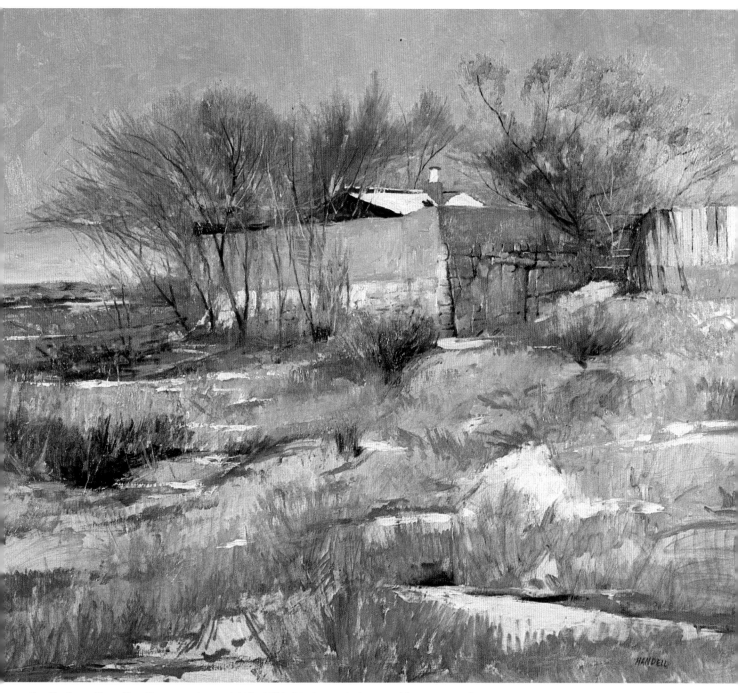

OLD ZIA ROAD, SANTA FE, *oil on masonite panel, 30" x 36" (76.2 x 91.4 cm). Courtesy of the Ventana Gallery, Santa Fe, New Mexico.*

Old Zia Road is still today a dirt road with a rural feel. This painting of the area is a high-keyed painting, with very light, bright colors that beautifully portray the general feeling of luminosity of the subject. The subject was bathed in a late morning sunlight below a cloudless blue sky. The warm earth tones were painted transparently, the sky painted opaquely for contrast. The paint quality of the old adobe is a subtle interweaving of transparent and opaque colors that are close in value. The foreground area leading up to the old adobe is painted broadly and transparently with the clear calligraphy of brushwork shown. The calligraphy of the broad brushwork and the transparent passages of color bring vitality and luminosity to the painting.

PORTRAIT OF PETER MARTIN, *pastel on sanded board, 16" x 22" (40.6 x 55.8 cm). Courtesy of the Ventana Gallery, Santa Fe, New Mexico.*

In the painting above, there is a solid sense of weight to Peter's head resting on his hand. In order to obtain this, I needed to place his portrait snugly into his hand, gluing them together in a sense so that the head would not seem to be floating. This meant giving up part of the portrait that was covered by the hand. The feeling of the weight of Peter's head being braced is reinforced by the angles of the left arm and those of the lines of the zipper on his blue sweater. They seem to form a weak triangle, which as a single shape would not support the weight of his head. To balance this awkward triangle, the area to the left of the portrait becomes important. Peter was sitting on a lightweight folding chair of interwoven yellow webbing. I painted the strong yellow of the webbing in order to pull the eye to the left. This, along with the conceptual sense of the pose, helps bring out the portrait.

For the composition at right, a feeling of weight is achieved by panning in on the adobe building and locating it centrally. I keep the shape of the adobe and the surrounding objects—as well as the light and shade—large and clear. For example, note the large shapes of the surrounding trellis and the white fence to the left. The shadow shapes formed by the overhead light are also large and bold. This all adds to the general sense of weight that exists throughout the painting.

ADOBE SHADOWS, *pastel on sanded board, 16" x 22" (40.6 x 55.8 cm). Collection of Dr. and Mrs. John Burk.*

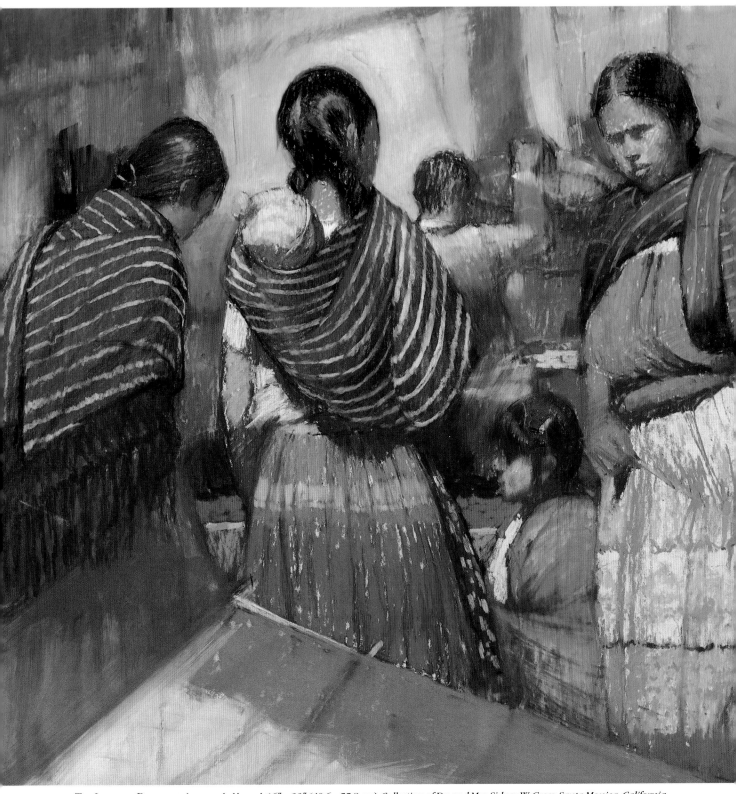

THE LADIES IN BLUE, *pastel on sanded board, 16" x 22" (40.6 x 55.8 cm). Collection of Dr. and Mrs. Sidney W. Gross, Santa Monica, California.*

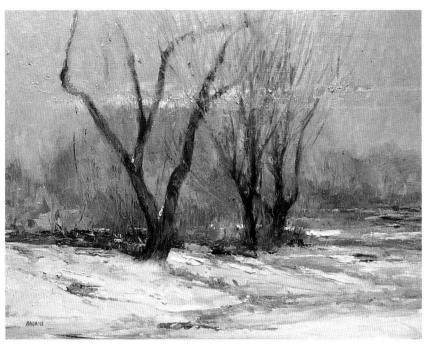

NEW MEXICO WINTER, *oil on masonite panel, 18" x 24" (45.7 x 60.9 cm). Courtesy of the Ventana Gallery, Santa Fe, New Mexico.*

In the painting above, *New Mexico Winter*, there is a lovely sense of atmosphere, which is achieved by having only the foreground area in focus. The trees in the background seem to want to melt softly into the sky. In landscape painting, atmosphere is more evident, especially when you are painting a lifting fog or a very humid day; the distance loses its details, shapes of objects become soft, and edges are blurred. The more soft edges there are in the background, the better the sense of distance and atmosphere you can evoke throughout the painting.

The setting for the painting at left is Patzcuaro, Mexico, an area where people still wear colorful handmade clothing. My center of interest in this painting is the ladies in blue rebozos standing, talking to one another in a busy marketplace. I designed the surrounding areas of the composition to be secondary. If too much consideration had been given to them, they would have competed with the ladies in blue, breaking up the kind of atmosphere I wished to create. I achieved this particular sense of atmosphere by placing the background figures in front of a practically transparent cloth. I then dramatically blurred a lot of edges, which immediately gave the composition a feeling of air and space and allowed the viewer's eye to automatically arrive at the center of interest.

# Tension

Compositional tension refers to tightly knit paintings. It is unrelated to literal, or pictorial, tension, which receives its sense of tension from the subject and is illustrative. Compositional tension is a spatial sensation of "static" activity that creates a dynamically alive painting and can intensify the weight and communicativeness of a painting. This feeling can be created by the pull between planes, by their particular shapes, colors, tones, and textures, and by their placement in the painting.

With regard to shapes, all shapes are in some way variations on circles, squares, or triangles. The variety of these shapes is endless. All are statements of potential interaction that could cause tension in themselves. Subjectively distorting selected shapes can add dynamic vitality to the composition.

The subjective use of directional lines can also create a sense of compositional tension. The same is true with color, values, textures, or any of the compositional elements. In a sense, tension can be defined as the attraction, repulsion, and interaction of the diverse compositional elements. Varying degrees of compositional tension can be built into a painting by choice, interweaving the elements of the painting in a balanced, tightly knit manner.

THE CATSKILL STREAM, *oil on masonite panel, 20" x 24" (50.8 x 60.9 cm). Courtesy of the Ventana Gallery, Santa Fe, New Mexico.*

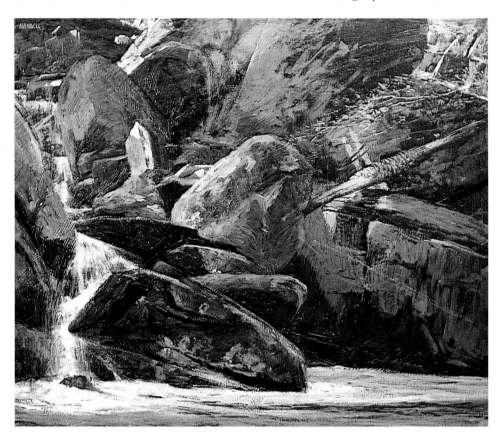

The nature of the subject itself—a random assortment of rocks with strong patterns of light and shade—can create a feeling of tension. In this grouping, there is no one rock that predominates over the other rocks, nor does the entire grouping stand out as one clearly defined strong shape. Because all of the shapes are small, they compete with and at the same time balance out one another, creating a sense of tension that intensifies the weight and communicativeness of the painting. The individual shapes of the rocks are strong and their arrangement in the composition solid. Visually, one has to work one's way through every area of the painting. The eye is allowed to wander throughout the composition. This movement of the eye balances out the cross pulling and the tension of the shapes, and compositionally keeps the eye in the painting. Thus, the viewer can appreciate the interest and sensitivity shown in the painting of the subject matter.

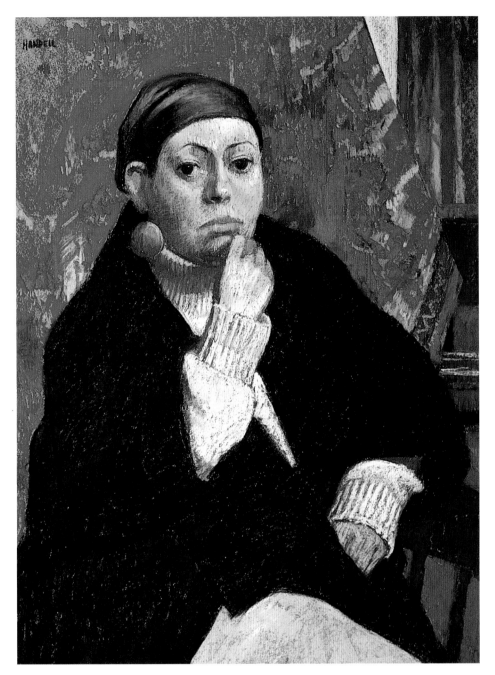

THE ORIENTAL RUG, *pastel on sanded board, 16" x 22" (40.6 x 55.8 cm). Courtesy of the Ventana Gallery, Santa Fe, New Mexico.*

Compositional tension refers to interaction among the diverse elements in a tightly knit painting. Here the feeling of tension is created by the interaction between the portrait and the richly colored Oriental rug and the numerous shapes, patterns, and details that make up the composition. This contrasts with the large two-dimensional flat shape of the black coat, which gives relief to all that is going on. The flat black shape of the coat also predominates, mostly because it is the largest shape in the painting. Although part of the design, the black coat, considered alone, is a broken shape and not strong enough to carry the painting. The design needs the remaining shapes to stand as a strong composition. The large black shape of the coat is cut by many smaller shapes that weaken it: the green skirt at the bottom, the left hand, the right hand and forearm. However, this shape acts in an important way by leading the eye up to the head and framing the shape of the head and neckline beautifully. Then, the patterns and shape of the complex Oriental rug (also very rich in color), complete with the suggestion of the studio behind it—compete with the shapes of the foreground portrait. This balance of tensions makes for a dynamically alive composition.

# Proportional Relationships

When you are composing realistic paintings, attention to proportional correctness and proportional relationships is essential, whether the subject matter is a portrait, a figure, a group of figures, a landscape, or a still life. Good proportion means that objects in a composition are in correct proportional relationship to one another. In turn, the relationships of the parts relate proportionally to the whole. Here, the ability to see and think as an artist does is again extremely important because it is necessary to depict things as they actually appear and not as we imagine them.

Good proportions and good proportional relationships result from solid training in basic drawing and a lot of practice. Without basic proportional training and forethought, actual proportions can elude us. We might focus on the things that are important to us, making them larger than things that we find unimportant. Unless one is well trained and experienced, it's hard to keep things in a proportional relationship. But done correctly, good proportions and proportional relationships will give your compositions a strong sense of reality.

In composing realistic paintings, attention to proportional correctness and proportional relationships is essential, whether the subject matter is the portrait, the figure, a group of figures, the landscape, or a still life. Good proportion means that the objects are in correct proportional relationship with themselves. It also involves the correct proportional relationship of one object to another and of all of them to the whole. When you are painting subject matter, such as rocks, rushing water, and trees, each area is terribly important and has a particular interest all its own. In order for the entire composition to hold together, the proportional relationships of every object must relate to every other; otherwise they will look awkward. At times, placing a figure or animal in the landscape helps clarify proportional relationships. However, I go for the feeling of rocks, water, and trees—an essence of nature—and work to balance the proportional relationships to express this reality.

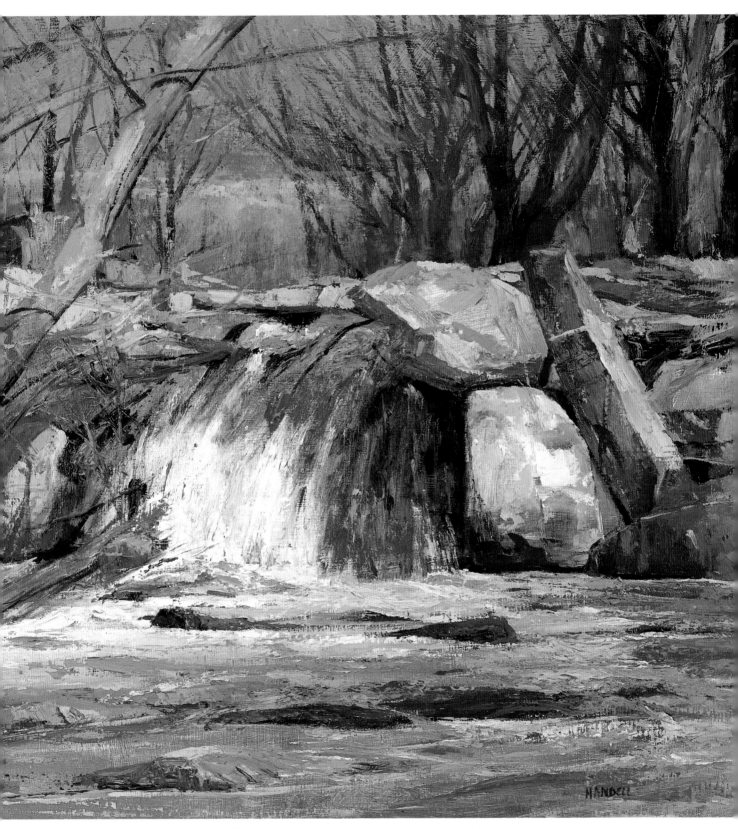

PECOS WILDERNESS, *oil on masonite panel, 20" x 24" (50.8 x 60.9 cm). Collection of Mr. and Mrs. John McCune.*

# Linear and Aerial Perspective

Both linear perspective and aerial perspective are explanations of how we see the actual world, make order out of this material world, and comprehend it. They help the painter construct space and scale in a picture. To this degree, understanding perspective is important to composition, for it is a means of grappling with the visible world for the purpose of reproducing it in a realistic painting. It enables the painter to present a sense of depth and space through the illusion of distance. With it, the artist can reproduce the correct visual changes and angles of planes, the sizes and planes of objects as they appear in three-dimensional space, and record them onto a two-dimensional surface. The use of perspective in composition means that we get a logical difference in scale between near and far objects.

"Eye level" refers to the painter's eye level. When you are looking out at the ocean, for instance, it becomes flat as it reaches eye level. Our eye level becomes the horizon. Thus, eye level is subjective, and the horizon changes as the viewer's eye level changes.

How the shapes and planes of objects are included into compositions is directly affected by the viewer's eye level. When objects are directly at eye level, we see neither the top nor the bottom planes. The front, side, or back planes are more prominent. We would most often see only one plane, either the front, the back, or a side plane. Sometimes two planes would be visible: the front and side plane or the back and side plane. With relation to the directional lines of the objects as they recede, lines above the horizon tend to slope down toward it. Lines below the horizon tend to lead up toward it. Parallel lines appear to converge at a point on the horizon.

Realistic painting relies heavily on the principles of linear and aerial perspective. Linear perspective in composition is also concerned with diminishing the size of objects and decreasing spatial intervals as they recede. When something is out of perspective, it indicates that the lines of the planes are incorrect in their receding angles; the planes are out of relationship; or the sizes of objects are awkward as they recede and do not relate.

Aerial perspective, on the other hand, creates the illusion of spatial depth by imitating atmospheric changes on colors and their values, and on the lost and found edges of lines. The distant objects and lines become hazier. This is based on the principle that as objects recede into space, there is more atmosphere between the viewer and the objects.

THE NEXT DAY, *pastel, 15³⁄₄" x 21¹⁄₂" (40.0 x 54.6 cm). Private collection.*

Parallel and aerial perspective show distance and give depth to a painting. Parallel lines seem to converge and colors seem to lose their local color and become a gray or blue gray as they recede. That's because of the added moisture in the atmosphere between the artist and the background.

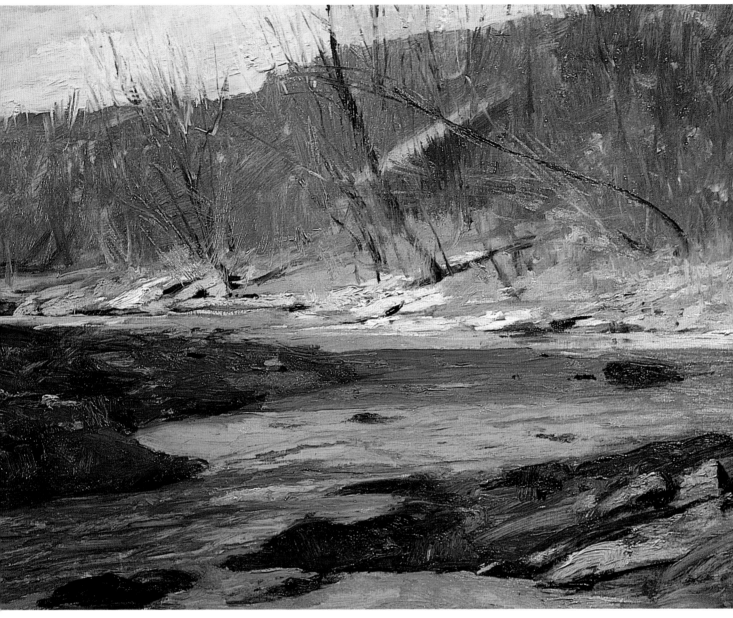

WOODSTOCK STREAM, *oil on masonite panel, 12" x 16" (30.4 x 40.6 cm). Collection of Edgar J. Davies.*

*Woodstock Stream* is a subtle landscape, designed and painted completely on location. The subtle perspective of the composition allows the eye to rapidly enter the painting. The baseline of the water and the streambed in the middle distance, which is at eye level, pulls the eye into the painting. The top line, representing the earth mass that separates the sky from the earth, seems to be diminishing in perspective. Linear perspective is also involved with diminishing the size of objects as they recede. Note how the sizes of the rocks get smaller as one enters the painting, again giving a sense of space through perspective. Also, the foreground and middle ground areas have the most detail and richest colors. As the painting recedes into the background, the colors become muted, the details vague. This is owing to the effect of the aerial perspective of the painting, which brings out the atmospheric changes in colors and their values and the softness of edges as objects recede.

# Lines and Subjective Lines

A line can be defined as an area where one color ends and another begins, where one object or area ends and something else begins. Lines divide space. As outlines, they delineate and usually separate objects or areas of a composition. Lines delineate the form of the subject, its movement, and can even express its rhythms. Through lines and with the help of tonal values, we can feel the density and weight that make the subject come alive.

In a composition, lines move dynamically through space. All lines point in some way, setting up directions. Strong linear designs, straight or vigorously curving lines, or forms delineated by sharp edges, all tend to create definite directions. All play an important part in the design of a painting. Lines can at times have an unstructured effect to them, and depending on how they are incorporated, they can either reinforce or interfere with the shape relationships of the composition.

Lines make contours. A contour is an edge as the painter conceives and feels it. It is subjective. Subjective lines are felt or implied directions to be visually completed by the observer. They can be part of both pattern and space and contribute to dynamic movement. Subjective lines can also consist of many smaller unattached directional lines that when combined form one dominant, implied directional line or rhythm. These implied or subjective lines can also be used to strong advantage to visually unite the foreground and background and many other areas.

In composition, lines can move dynamically through space. All point in some way, creating definite directions. Within the masses of this composition are many lines forming movements that flow in and out of the painting. There are the lines of the cast shadow that cross the ground plane; the linear makeup of the coyote fence on the right; and the linear angular cast shadows of the vigas, or beams, of the adobe building. All of these lines are literal. Subjective lines are felt or implied directions to be visually completed by the observer. These are evident in the sunlit snow patches and the tracks that lead into the painting. Together, all these lines guide the eye in and out of the composition, leading it to the center of interest, which is the tree and the areas of adobe and fencing adjacent to it.

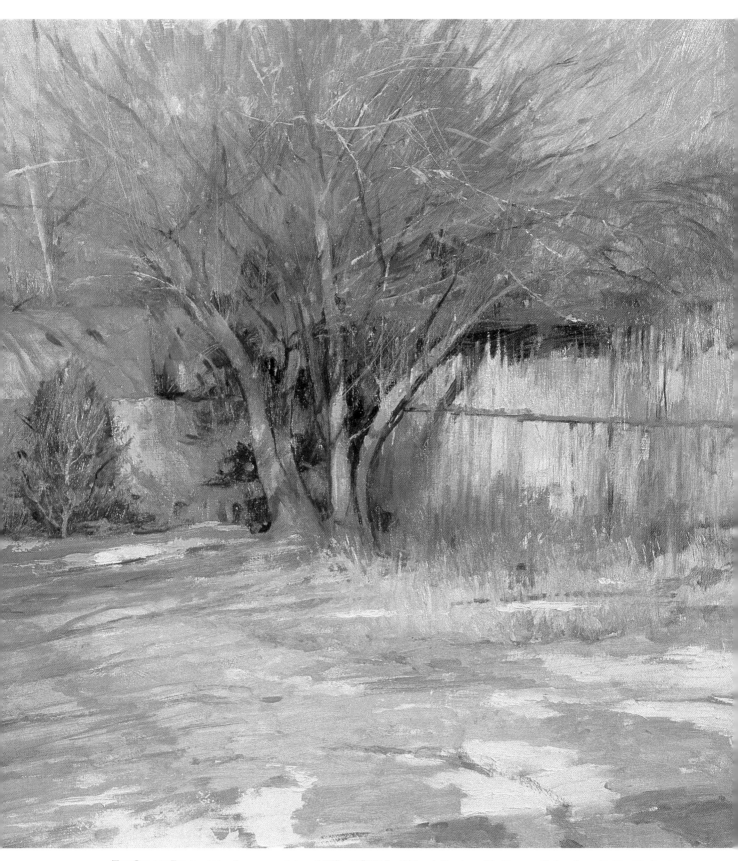

THE COYOTE FENCE, 1988, *oil on masonite panel, 20" x 26" (50.8 x 66.0 cm). Courtesy of the Ventana Gallery, Santa Fe, New Mexico.*

# Part Four

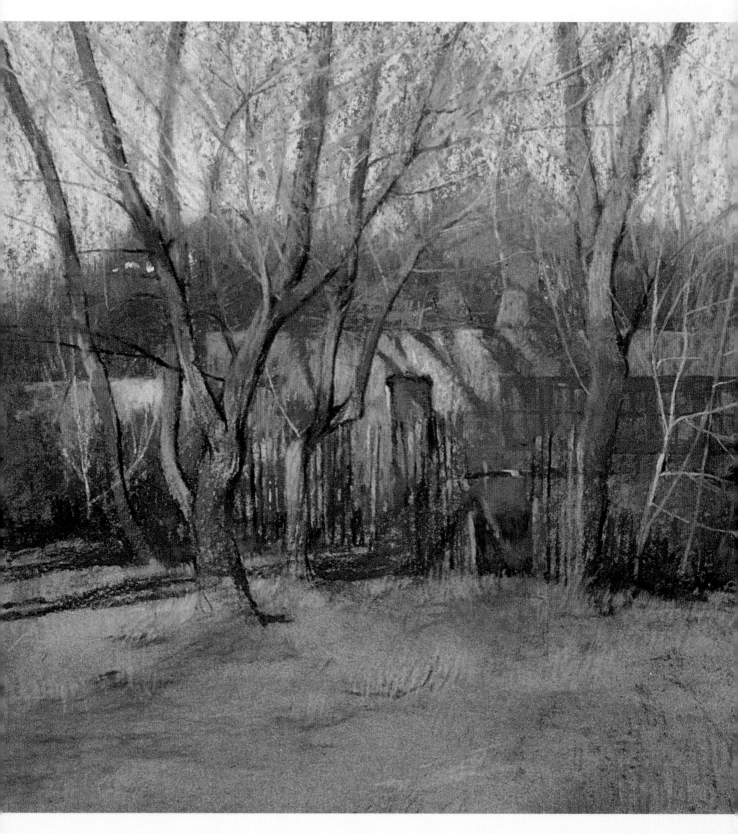

# CREATIVE APPROACHES

*"Whatever subject you choose to paint, listen to your innermost feelings. You won't always be able to verbalize why you choose to paint a particular subject in a particular manner, but when the feeling is there, you will intuitively know what you're looking for."*

# The First Impression

The first impression—that initial response to the subject—is very important to realistic painting. You are already excited and emotionally involved with the subject, which is why you chose it in the first place. It's important to be aware of this and to recognize that this is the external impetus that triggers you internally. I keep it in mind as I design each composition. With a fresh eye, I harmoniously interweave the subject matter and the elements of the composition. Although both intuition and intellectual decisions are involved, as much as possible I allow intuition to lead. I do not intellectually conceive geometrical shapes and then work out of them.

As I analyze what made up my first impression, I try to abstract it into primarily large shapes. My eye then scans the subject matter and tries to group forms, as much as possible, into secondary shapes. I focus in on the design elements, sensing and feeling them as I work. After a while I am able to determine the dominant shape and any important supporting shapes and relate them to one another. As the structure becomes clearer, the composition grows and develops, and that first impression starts taking shape on the canvas. I go from there, never losing sight of the impact of the first impression.

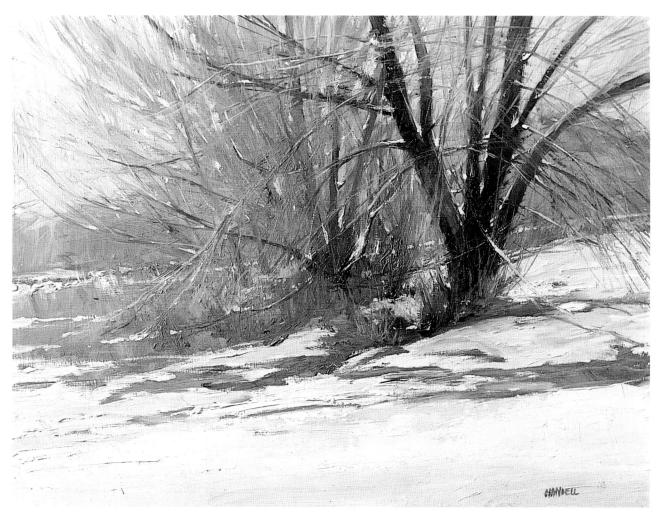

TAOS WINTER, *oil on masonite panel, 12" x 16" (30.4 x 40.6 cm). Collection of Elizabeth Mowry.*

Painted on location, *Taos Winter* is a complicated yet simplified landscape. It had snowed on and off the previous day and a bit through the night. By midmorning the next day the snow had stopped and the beautiful Taos landscape was hidden under a lovely white blanket. Snow again threatened from the moisture-laden sky, so I knew I did not have much time to work. I chose a small canvas because of the time limitation and picked a subject that evoked a strong initial response. The first strong impression of this painting is based on only five distinct values: the cool background sky color, the background bluish gray trees, the rich warm siennas of the ground plane, the dark values and rich colors of the foreground trees, and the cool off-white color of the light snow.

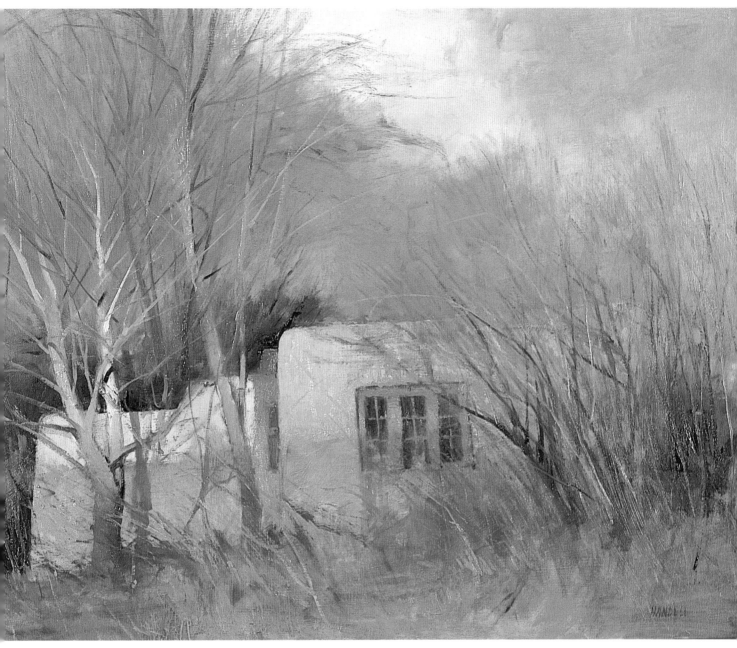

BLUE WINDOW, *oil on masonite panel, 18" x 24" (45.7 x 60.9 cm). Collection of Jerry and Sandy Weigand.*

Brilliant, luminous light hitting the yellow adobe building and reflecting in a rich deep-purple sky was a strong, dramatic first impression. The painted variations of the sky and the foreground details were secondary to this deeply felt first impression. This is the secret: to establish that strong first impression and not let the details siphon power from it. The large turquoise blue window gives lots of interest and variety to the painting. The trees and bushes in front of the adobe add to the reality. But, in this painting, it's the striking light effect that secures the powerful first impression. Everything else remains secondary.

# Center of Interest in Composition

For me there is usually one center of interest in a composition. At times there are also submotifs that can accentuate the main center of interest. Once you are intuitively in touch with your center of interest, you can work to harmoniously interrelate it with other components of the composition.

A powerful composition is achieved when the center of interest is reinforced by the design. Remember that too many objects, shapes, or details—all competing for attention—can weaken the composition.

Keep in mind the aspects that make up the center of interest as you develop and feel your way through a composition. Seeing the center of interest as a part of the whole is important. Equally important is focusing in on it, realizing that this is where you want the viewer's eye to go.

The center of interest—the woman standing folding a rebozo—is obvious and strong. She is surrounded by colorful folded rebozos lying about on a display table. Her image was so strong and clear that I was able to paint her in a striking half light, playing down the expression and features of her face. By playing down the facial features—the illustrative part of the center of interest—and by playing up the strong light and shadow patterns, I was able to achieve a painterly quality. I kept the richest colors for the rebozos lying on the table. This choice helped balance the viewer's attention with the center of interest. I kept the rest of the composition simple.

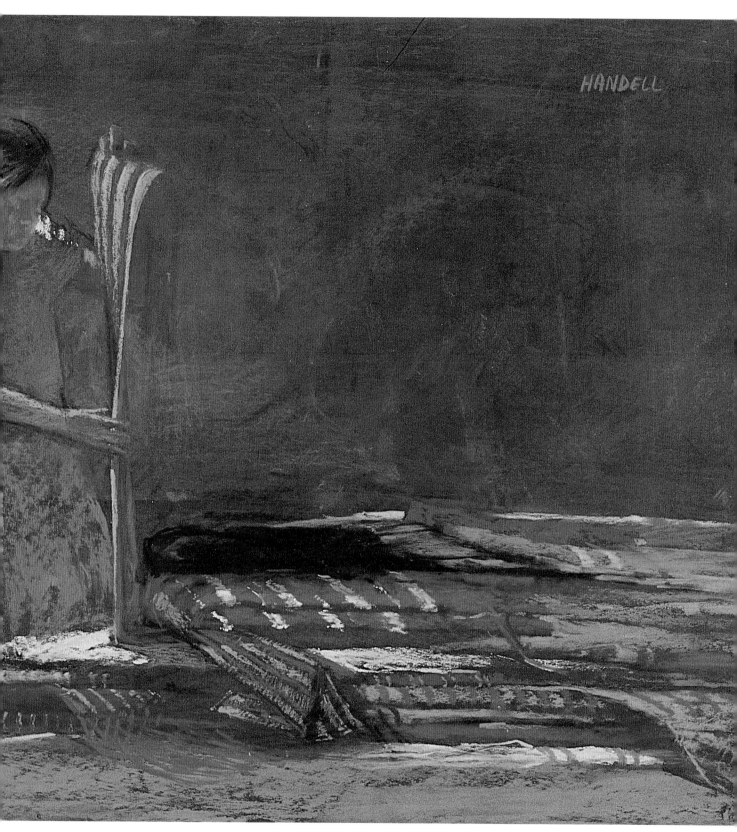

THE REBOZO LADY, *pastel on sanded board, 11" x 16" (27.9 x 40.6 cm). Collection of Mr. and Mrs. James D. Parks.*

# Artistic License

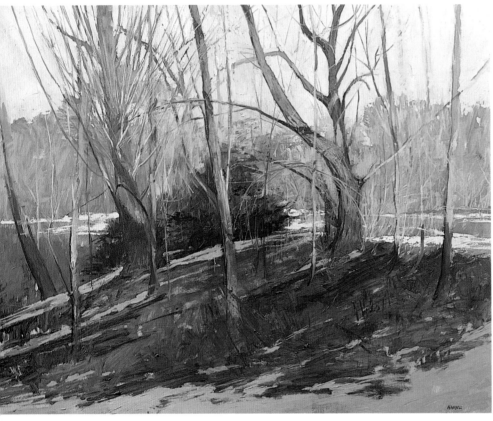

FEBRUARY, WOODSTOCK, NEW YORK, *oil on masonite panel, 24" x 30" (60.9 x 76.2 cm). Collection of Bim and Diane Moncure.*

When I started this painting, there was a lot of detail in the background. Upon analyzing what I had in front of me, I realized that the background competed equally with the foreground, which divided the composition in an uninteresting way. Yet I knew that the makings for a wonderful painting were at hand.

Using artistic license, I decided to focus in on the foreground. I raised the placement and line of the foreground hill a bit higher than it actually was. This allowed me to look into the foreground more. I emphasized what I wanted there—the trees and the slope of the ground plane—and played down the details of the background. I made use of the warm colors of the background to suggest the play of sunlight in the distance. Nothing in the background has any detail to it; nothing in the background stands out. I just painted it with warmer, lighter colors and kept it simplified. That's all that was needed to suggest the background and give a sense of distance to the painting. Without proper use of artistic license, this could have been an overbearing painting. But what resulted instead was an interesting composition with strong carrying power to it.

The shapes, design, details, colors, texture, and luminosity of the subject, which originally caught the artist's eye with all its variant possibilities, are the features that determine the composition of the painting. The remaining elements are emphasized or de-emphasized in relation to the center of interest. This is where artistic license comes into play.

An understanding of the carrying power of a painting is needed in order to make correct use of artistic license. The carrying power of a painting is a very forceful and dramatic aspect. It is the solid strength of the basic underlying structure.

Once you realize where the center of interest is within the carrying power of the painting, then you can consider using artistic license to selectively work with other elements.

Since realistic painting can easily be cluttered with too much detail and result in a too busy, overcrowded, confused composition, artistic license becomes especially important because it allows you to pick and choose, determining how to strengthen the basic underlying structure of the composition as well as the fundamental realism of the painting.

Artistic license is not a license for bad drawing or bad painting, and it does not mean leaving out everything or anything because you don't know how to paint it or you don't wish to work on it. Artistic license is a valuable tool for the artist and requires skillful aesthetic understanding to use it well. Changes in the painting of the reality are related to the artist's response; they are not arbitrary. They derive from a response based on much experience, and they always relate harmoniously to all other aspects of the painting. A painting actually becomes more interesting because of the use of artistic license.

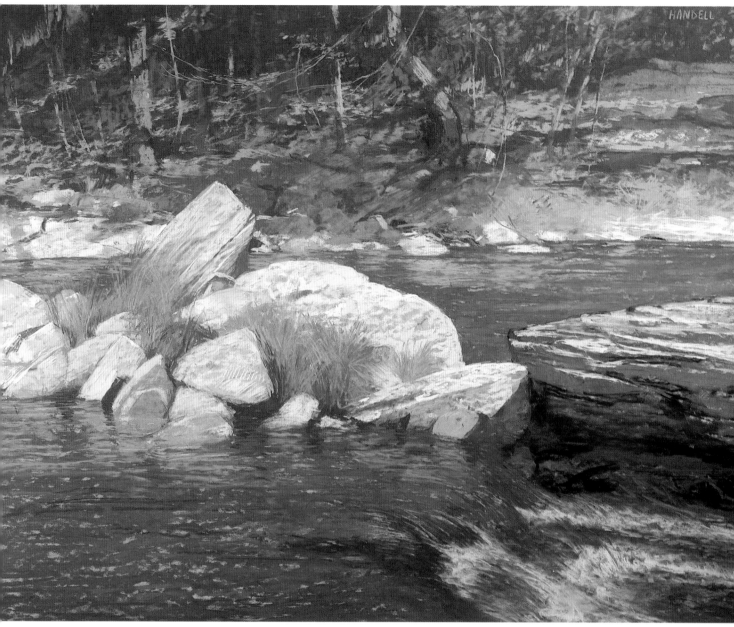

MOUNTAIN STREAM, WOODSTOCK, NEW YORK, *pastel on sanded board, 22" x 28" (55.8 x 71.1 cm). Collection of the artist.*

Here again it was a matter of playing up the foreground, the large rocks, and playing down the far side of the streambed that was competing with them. In the background embankment, there was a large whitish rock that was too close in size to the foreground rocks. I used artistic license and completely eliminated it, leaving the background simple and distinct from the foreground. This allowed me to focus in on the foreground rocks. While working on them, the light changed at one point to a dark, sharp cast shadow that cut across them and seemed to weaken their shape. I eliminated the cast shadow to preserve the impact of the foreground rocks and keep the carrying power of the painting clear and simple. This is another example of making good use of artistic license in composition.

# Composing from Life

There is nothing like working from life! It can be an exhilarating experience—especially when you work outdoors. It gives you the contact with your subject and the energy flow that injects life into an artist and into his paintings.

A realistic painter is not merely copying from nature. He is learning to see and to be alert at all times to the reality of the connections, the rhythms, the hinted-at shapes and values, the unexpected details, which are the life force of his subject. Sometimes these aspects are hidden amidst the variety, the confusion, the beauty of the perceived reality. As a painter works from nature, he sees, simplifies, and more and more readily chooses visual relationships.

There are so many subtle relationships in nature, in working from life. Many of these connections and relationships may seem arbitrary, but they are truly beautiful. As the artist learns to see, he sees that these relationships are fresh and spontaneous...and everywhere. When composing from life, he needs to integrate into the painting the reality he perceives in nature.

This process of composing from life is acquired through practice, and is a very important discipline to learn. Sometimes the use of a simple viewfinder can be very helpful.

SWIRLING BRANCHES, *oil on masonite panel, 16" x 20" (40.6 x 50.8 cm). Private collection.*

Here again, because I was focusing in on the complicated foreground, I had to play down the background. I first established the initial placement of the trees in the composition and the strong light and shadow patterns striking the tree trunks. Once this was established, the rest of the composition fell into place. I liked how important the delicate twigs and branches seemed as the light changed. They had to be drawn and composed with utmost care.

The background was composed with patterns of colors and values to suggest the nature behind it.

Remember that working outdoors from life is all-encompassing and very invigorating. It helps develop the artist's memory. He becomes aware of what's meant by the first impression. He sharpens his use of artistic license. He learns that much has to be simplified and eliminated to come up with a good painting.

Taos Magenta, *pastel on sanded board, 11" x 16" (27.9 x 40.6 cm). Collection of Mr. and Mrs. Lon Davis.*

Taos and its surrounding area has lots of intimate corners like these, which are a joy to stumble upon. When working from life, such serendipity can be an exhilarating experience.

Since time can be a problem when working from life, I like to work a bit smaller than usual. Here I was interested in the tree, the beautiful magenta color permeating the setting, the shifting light, the light and shade on the tree and the adobe, and the surrounding nature. Within minutes I had lightly established these elements. I kept to my initial design as I worked up the different areas of the pastel, even as the light changed before my eyes. That's the secret to composing from life: Make a commitment and stick to it. Whenever I fail to do this, I usually end up with a weak composition and a mediocre painting.

# Composing from Drawings

Drawing is a sort of visual diary that readily reawakens a visual experience. The time spent with the subject matter helps to fix an experience in the mind.

Good drawing will always show you what you're seeing, and weak drawing will point out where you're not looking. Try to draw without preconceived notions, and try to see clearly and deeply.

There is a great difference between composing from life and composing from drawings. In the case of a drawing, the artist has already spent much time with the subject. A translation of the subject onto paper in black and white has already been made, and a certain grasp of the subject has been achieved. The composition has been explored. It also becomes clearer which areas of the painting should be developed earlier and which should be saved for later.

It's a good idea to draw often; it is a discipline and practice that will reveal much to you about yourself. It will reveal how you see things, how you feel about things, what your interests and perceptions are, without the pressures of making a painting. You will soon find that you are looking deeply into the essence of things, and it is from this essence that your "sense" of composition will emerge. Slowly but surely you'll be able to compose and paint from your drawings, which is an art in itself.

When I compose from a drawing, I know I'm on my own with regard to the creation of the colors of the painting. I take this as a challenge rather than a handicap. When the drawing shown above was completed, I hung it on my studio wall. I enjoyed looking at it and wanted to use it in a painting. A couple of weeks later it snowed. I visited the tree . . . it took my breath away. The setting was so beautiful. I made another drawing, this time a quick sketch to capture the value patterns. Back in the studio, working from both drawings, I composed this painting. For me, the drawing worked as a diary; every time I looked at it, it brought back vivid memories that I incorporated into the painting. Yet, at the same time, I was able to compose freely on the canvas, since I wasn't restricted by my drawing.

Santa Fe, Snow, *oil on masonite panel, 20" x 24" (50.8 x 60.9 cm). Collection of Alan Frakes and James Young.*

MONDAY, *pastel on sanded board, 11" x 16" (27.9 x 40.6 cm). Collection of Alfred and Stephanie Lord.*

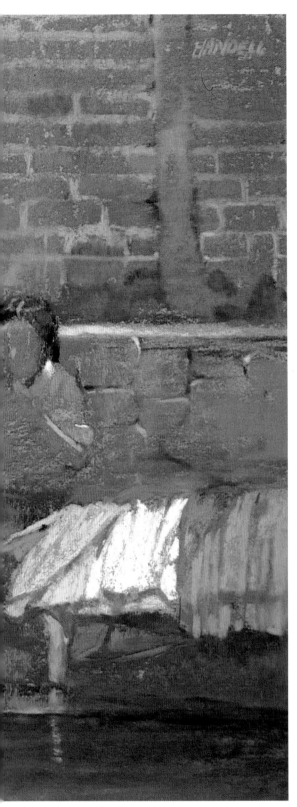

Groups of people make an ideal subject for study. The variety found in them is endless, and the best way to understand the truth of this is to constantly draw them. The heights, widths, and overall shapes they make are ever changing. And when you consider how one figure cuts off another, you'll realize how you can't be timid in this study. You must be decisive. You must look, observe, and respond. A subject such as this calls for lots of drawing practice and later the ability to compose in color what you are establishing in black and white as you make your drawings. This translation will take some time, but once you've done it, the casualness, the spontaneity, the sense of reality you obtain from drawings done from life will enter into your painting. I did a number of drawings for this pastel. One of them is shown above; it gives a good idea of how flexible the translation from drawing to painting can be.

# Composing from Photographs

Once you have developed a vision all your own, you will find that using a photographic image will be an aid to your personal vision. At times I begin compositions from photographs or slides by just looking at them and taking off from them, not copying them. This takes practice, years of experience, and previous work from life. When you work from a photo, I recommend that you first make one or several pencil drawings of the composition from the photo or slide before attempting to paint from it. This can facilitate the transition from photograph to painting.

When you work from a slide, usually you use only one slide, so as much of the information possible has to be there since all the composing and painting will be done from it. Slides best show the color and light found in nature. They are the truest photographic images and have the most exciting impact. But there is no negative.

When you work from black-and-white and/or color film, there is a negative, and lighter or darker prints and enlargements of areas can be made from the negative. A darker print will reveal patterns of the light and shade that make up the composition. But a lighter print will allow you to look into the shadow areas and see more information, which you wouldn't normally see in a darker print. Also, areas can be blown up to allow still more informa-

tion to be seen. More information will give you more flexibility when composing. Because you want this flexibility, nothing compares to the basic information and detail in black-and-white prints. With color prints detail is not as good, but of course you will get an idea of the color. I don't recommend relying on the color in a color print for color in the painting; this usually results in washed-out colors.

One of the main advantages of composing from photos is that a number of compositions can be done from one photograph by simply changing the light and shadow patterns or changing the focus. This variety of possibilities can be very beneficial for composition.

At times, I like to paint for half a day and just drift for the remainder, absorbing my subject matter, drawing and photographing. This black-and-white photo was taken with a long-range zoom lens. This type of lens is excellent for photographing groups within a marketplace. The people are captured in natural poses, completely unaware of being photographed.

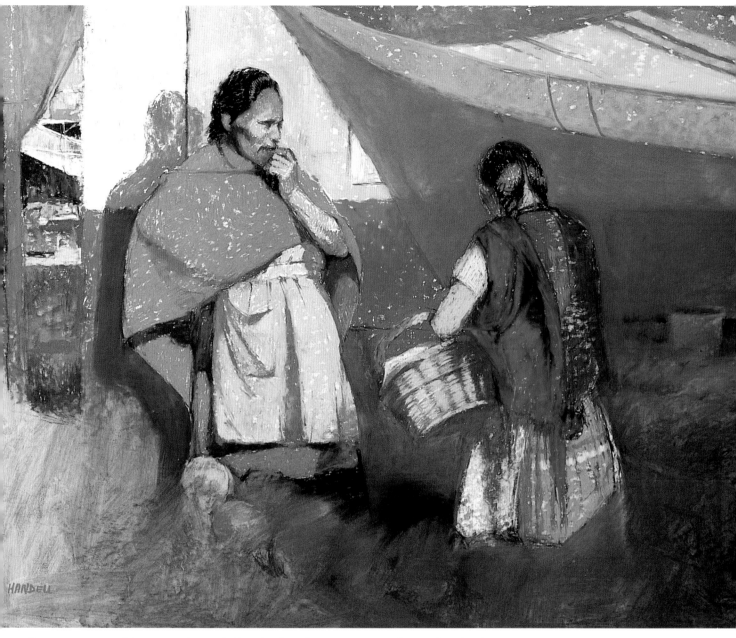

CONVERSATION AT THE MARKET, *pastel on sanded board, 22" x 28" (55.8 x 71.1 cm). Collection of Marilyn Eber.*

Here I used a relatively small area of the black-and-white photo shown at left to begin to compose an entire painting. The pose of the woman standing with her hand on her chin truly interested me, whereas other areas of the photo did not. I also liked how close she was standing to the open doorway. I focused in on her, then placed her image off-center into the painting. I composed everything else around her, making sure that the second figure in the composition didn't compete with her. I was on my own for the color, which gave me a field day. But, again, remember that the sense of reality from the color was achieved by having spent a lot of time on location with my subject.

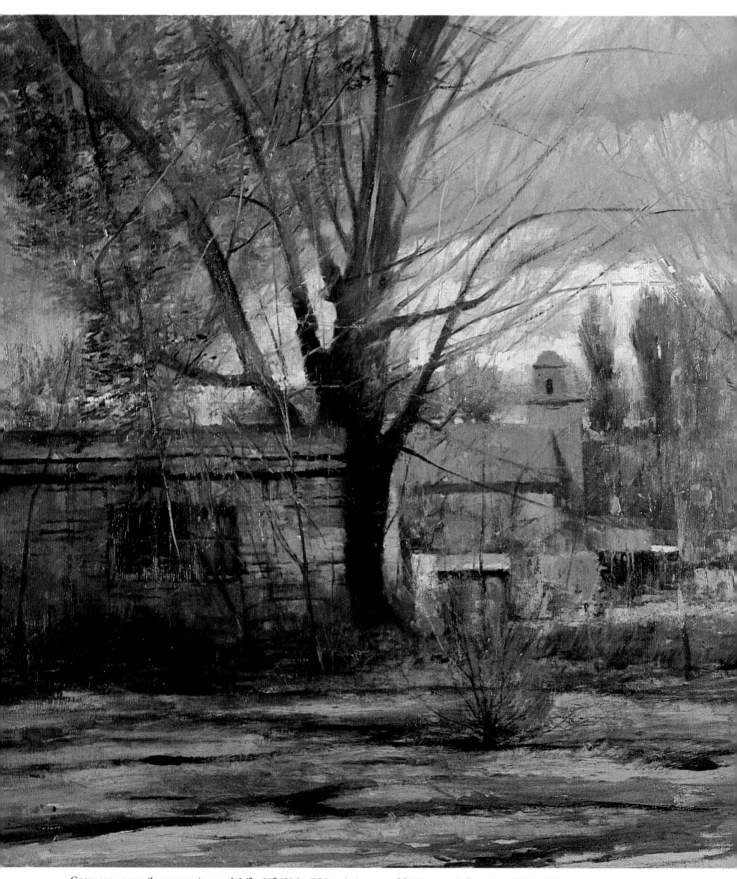

CORRALES, 1988, *oil on masonite panel, 24" x 30" (60.9 x 76.2 cm). Courtesy of the Ventana Gallery, Santa Fe, New Mexico.*

By knowing your subject and by gaining lots of experience from working on location, it is possible to work creatively from photographs. Although I like the photograph above just as it is, it didn't clearly show what I was interested in behind the foreground foliage—a suggestion of buildings surrounding the church. In the composition of the oil painting of *Corrales*, the foreground foliage is played down and the background buildings are suggested. You have the latitude to change what you want to when working with a photograph. In the studio you have time to analyze your painting as you are working and developing it. You can consider what the painting needs in order for it to be more exciting, more fulfilling, more resolved. Again, for this you will need familiarity with your subject, which is usually obtained by working regularly from life. But you must understand light, for you will be doing lots of creative composing with regard to lighting conditions and color. Photographs are good to take off from but not to rely on for color. Taking photographs of your subject is a good way to work into painting from photographs by using your own photographic images. This is how the painting *Corrales*, 1988 was done. While on location, I made a twenty-minute drawing and took black-and-white photos before and after the drawing was completed. Back in the studio, I relied on the photographs and my memory to compose and paint this image.

# Placement

Placement in a composition is a crucial element and can be very subtle. Relating placement to feeling is important to good composition, and placement in a sense depends upon the kind of feeling you want to express about a subject.

In my early days, the placement of things on a page meant composing and goes back to my studies at the Art Students League of New York, where I studied drawing with the late Louis Priscilla. The objective then was to first simply analyze the shape of the entire figure and place that shape as large as possible onto the sheet of paper being worked on. This was the most important consideration before even beginning with the drawing of the figure.

The above male nude drawing, done some twenty-five years ago while living in Paris, is a good example of this study in placement. I remember doing this particular drawing as though it were yesterday, leaving out the features, not wanting to do more than just suggest the position of the head. The head was in a slight shadow, and I wanted to tie that shadow up with the cast shadow it threw on the chest, thus tying both areas up as one strong mass of shadow. I felt the placement and the shape of this mass was important, and I wanted it to be seen that way, without the details attracting the viewer away from this design concept. In this drawing I was concerned primarily with the placement of the nude on the page, the sense of weight the body had to it, and the beautiful light that was illuminating the nude.

The placement of the center of interest affects the entire painting, and its compositional placement should always be determined in relation to the whole surface shape. Whether I'm working from life, a photographic image, or a drawing, I like to gaze at the blank canvas and visualize the subject transferred onto it. I do this without pencil or brush—with nothing in my hand. I try to slow down, get everything out of my mind, and after a while, I

SEATED MALE NUDE, *Charcoal on Paper, 22" x 28" (55.8 x 71.1 cm). Collection of John Ronald Dennis.*

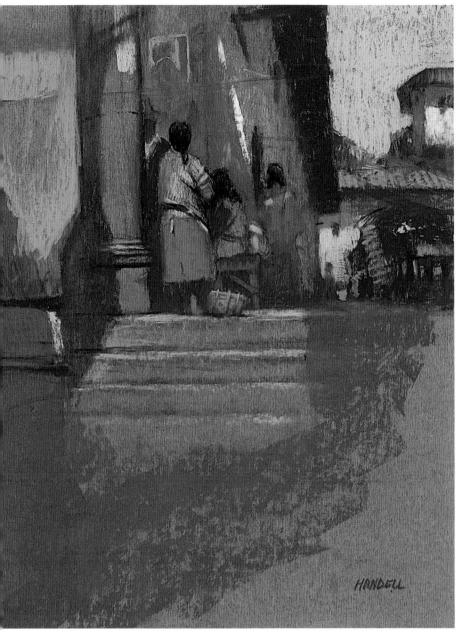

MARKET STEPS, PATZCUARO, *pastel on sanded board, 11" x 16" (27.9 x 40.6 cm). Courtesy of the Ventana Gallery, Santa Fe, New Mexico.*

In this painting, the eye level is a low eye level, somewhere well below the top step. The upper half of the composition is compact, dramatic, and detailed. Everything of interest is interwoven and placed above the all-important line of the top of the steps. It's the tight placement of things above that line and the comparative emptiness below it that makes this composition unique and exciting.

allow my fingertips to map out the placement of the subject matter and I intuitively begin designing the composition through the placement of things. It's a bit like zen painting.

Placement of the subject and the center of interest either at the top, the bottom, or to one side of the surface also creates endless possibilities for variety and dramatic effects. When the center of interest is placed at the top, there will be more space in the bottom area of the composition as the eye is pulled up. Placement of the center of interest at the bottom of the surface often creates a dramatic composition because eye level has a very realistic feel to it. Placing the center of interest to one side of the surface creates a visual movement to that one side, and careful placement is needed in order to create a balanced composition. The use of empty space as an integral balancing or contrasting shape can complete this type of placement.

Essentially, however, no matter what placement is chosen, a basic harmony and balance to the composition is being sought, and all subordinate areas of the composition must be harmoniously related.

# Simplifying Shapes and Unifying Compositions

Realistic painting is an art in which the visual order of things, the realism, combined with the degree of detail you wish to include, and the elements of design, shape, and placement are interwoven into a composition. Realistic painting works to simplify matters and to create a deeper order out of surface disorder. Disorder is confusing and creates weak compositions. Thus, simplifying, changing, and modifying shapes is important to creating a strong unified composition. Among other things, the artist tries to grasp an illusion of the third dimension, capturing as much volume, space, and luminosity as possible while designing the composition through shapes, large and small, which are es-

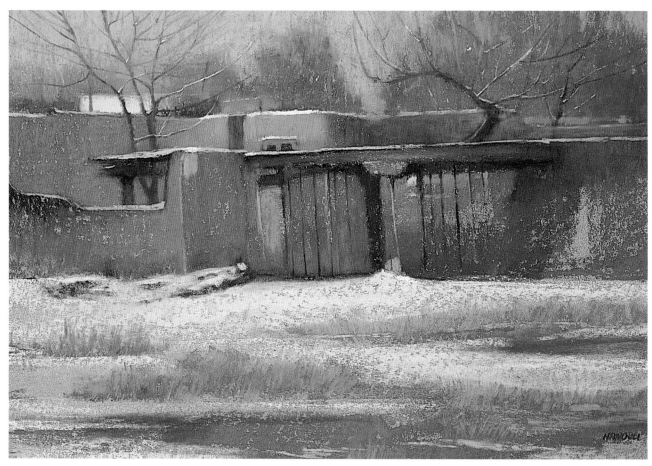

LAST LIGHT, SANTA FE, *pastel on sanded board, 11" x 16" (27.9 x 40.6 cm). Courtesy of Bernyce Besso.*

The subject in *Last Light, Santa Fe* is a complicated arrangement of forms and shapes. The buildings with their various colors and shapes are surrounded by trees and a dramatic sky. The composition is divided practically in half. The bottom half gives relief to the top half. I unified the top and bottom halves of this composition through the strong use of color temperature and softly blended edges. I chose a small area to receive the warm late afternoon light. The rest of the objects in the painting are unified by keeping all their colors very cool and muted. The shapes are further simplified and massed together by softening the edges of the buildings in the shadow area. The warm lights sing out, pulling the viewer's eye to them. This contrast allowed me to further simplify the shapes in the large shadow area, unifying the composition yet allowing me to keep a sense of detail and variety.

sentially two-dimensional in concept. But the use of two-dimensional shapes helps the realistic painter achieve that sense of three dimensions.

One of the most common causes of disjointedness and lack of unity in a composition is a lack of connection between areas or just weak massing of areas. Thus, the massing of the different areas of the painting is perhaps the most important element involved in simplifying shapes and unifying compositions.

The final carrying power of the painting is only as strong as its underlying compositional structure, and the shapes and masses are what make up the underlying structure of the composition, which allows first things to be seen first. If the shapes are not simplified enough or not simply massed, the composition will be weak. But massing of the painting also depends on how the light, dark, and cast shadow relationships of the shapes combine—not only on the shapes themselves.

When focusing on a central shape or object, outer areas should not become too busy and draw attention away from the central mass or shape. Darker areas of a painting, which can't be seen into as easily, mass more easily into simplified large shapes. On the other hand, in the light areas where we can see into them more readily, they usually have more of a value range and variety to them and are therefore harder to simplify. Yet they must be simplified. If the light areas are not well massed and simplified, the entire painting will have a jumpy, disconnected feel, usually with unimportant detail taking over. Correct massing will always simplify shapes and eliminate unimportant details. Within the massed, simplified shapes, much variety, activity, and detail can then occur.

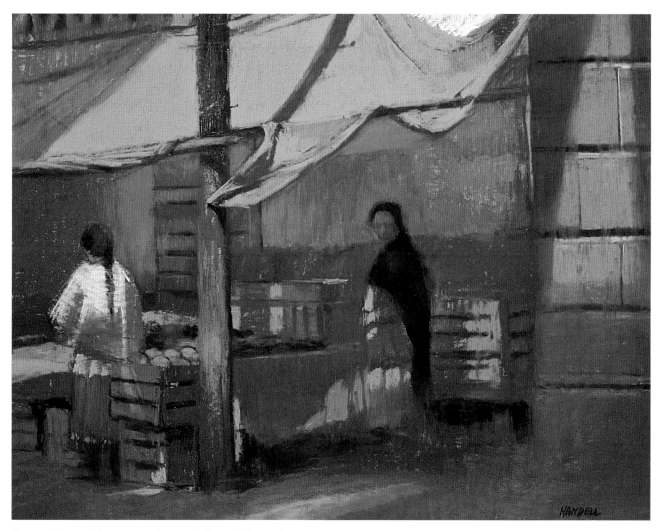

THE RED AWNING, MEXICO, *pastel on sanded board, 11" x 14¼" (27.9 x 36.2 cm). Courtesy of the Ventana Gallery, Santa Fe, New Mexico.*

Here again is a complex subject with many shapes to it—the still life of a marketplace, the people, crates of fruits and vegetables, individual crates stacked upon one another. All combined makes for a complex arrangement of shapes. To simplify these shapes and unify the composition, I made use of the red tones of the translucent light that permeates the painting. These strong yet subtle red tones are part of the cast shadow thrown by the red awning, which is blocking the sunlight from hitting the subject. Market vendors use these awnings to protect their produce from exposure to direct sunlight. The massing of the subtle yet striking red tone of the awning helps to unify and simplify the shapes of the painting, resulting in a striking composition.

AFTERNOON VERANDA, *pastel, 11" x 15½" (27.9 x 39.3 cm). Collection of Dr. and Mrs. Thomas M. Hudak.*

Here, the simplified abstract shapes are so strong that they carry the painting. All the details are played down or are eliminated. Yet there is a strong sense of reality. The feeling of the late afternoon light shows up beautifully. Each area, though simply stated, is rich in color.

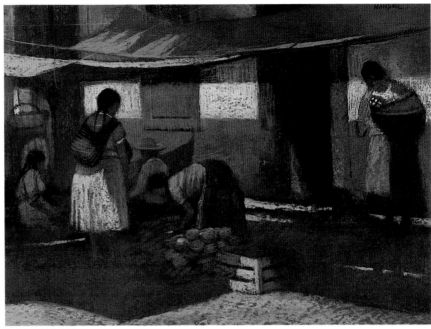

MOMENTS OF CHOICE, *pastel, 15¹/₂" x 21¹/₂" (39.3 x 54.6 cm). Courtesy of the Ventana Gallery, Santa Fe, New Mexico.*

In the pastel painting above, the figures weave in and out of a very strong cast shadow thrown by the overhead awning, which helps bind together the entire composition.

# Dynamic Effect of Close-up

While I was a student of landscape painting, it was suggested to me to push the center of interest away and place it into the painting within a setting. Then, to allow the first fifty yards or so, which should be the bottom foreground area of the canvas, to be used to lead the viewer's eye into the painting. This is a traditional approach to realistic landscape painting and it's a good approach. However, at times I like focusing in, close up to my subject matter. There is an intimacy and intensity with the close-up view that I like. The resulting compositions are a combination of abstract shapes married with realism. The shapes are larger, clearer, and more intense. The design of the composition, interwoven with the details of the reality, come more sharply into play.

With regard to portrait painting, again I am more interested in the psychological aspects of the sitter: the expression in the eyes and the beauty of the nuances of form and color as they change within the small and large areas of the portrait, in the skull and face. These nuances and all that's involved with them become my primary interest and focus, creating intense, dramatic, psychological portraiture. Simple tones and textures become the backgrounds that make up the negative, surrounding shapes that support the dynamic effect of the close-up of the portrait and help finish the painting in a simple manner.

This painting shows a detail of an old and very interesting adobe building in the heart of Santa Fe. At first, as I viewed this adobe and tried to place all of it onto the painting surface, it didn't work, for it lost the impact of size and character. Adobe structures have an aspect of bulk to them, being full without feeling large. It wasn't until I eliminated certain sections of the building and found what I wanted in a small area that I captured the general sense and size that I needed. As I panned in on the building, it became more dramatic. The whole scene became more exciting and dynamic. After initially establishing composition, the painting began painting itself in a quick succession of intuitive insights. Panning in on the adobe gave the building and the entire painting a dynamic effect, and the area surrounding the building became a suggestion of what peripheral vision would see of rich green summer growth. Adobes blend with the earth and the surrounding natural landscape. Since I was attracted by this aspect of the subject, I allowed for hints of the surrounding nature to add to the dynamic effect of the close-up.

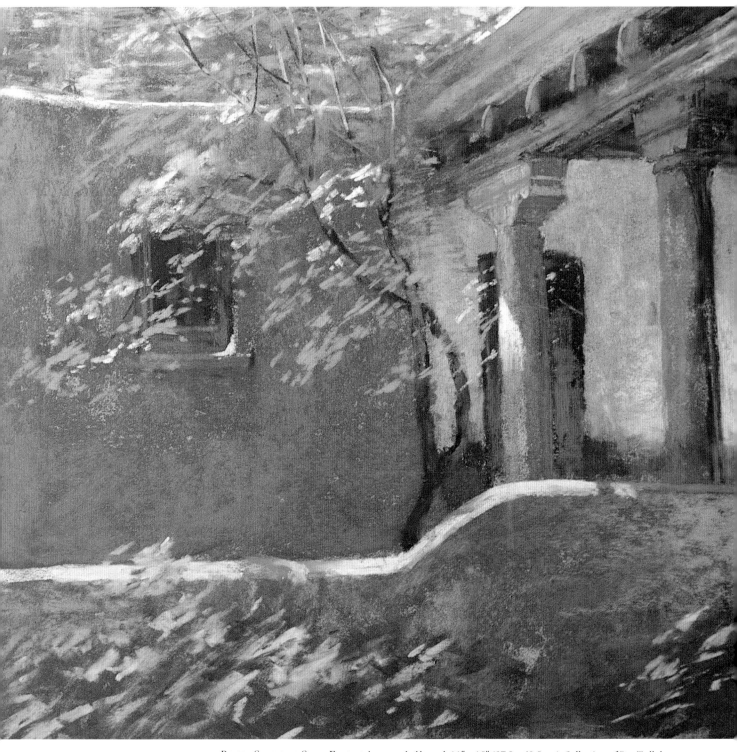

PORTAL SHADOWS, SANTA FE, *pastel on sanded board, 11" x 16" (27.9 x 40.6 cm). Collection of Ray Tulloh.*

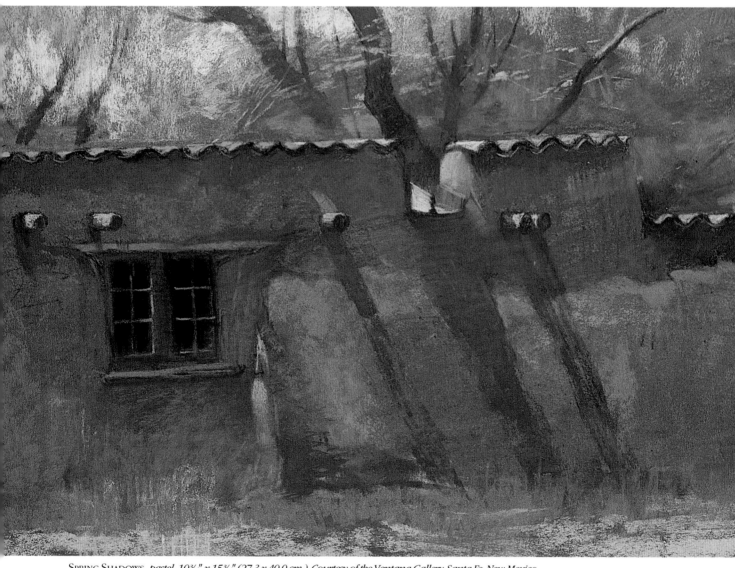

SPRING SHADOWS, *pastel, 10¾″ x 15¾″ (27.3 x 40.0 cm.). Courtesy of the Ventana Gallery, Santa Fe, New Mexico.*

In this pastel a large area is designated for the adobe and a comparatively small area is left for the background. It's the dramatic but subtle use of light and shadow that cuts across the adobe that helps unify the composition.

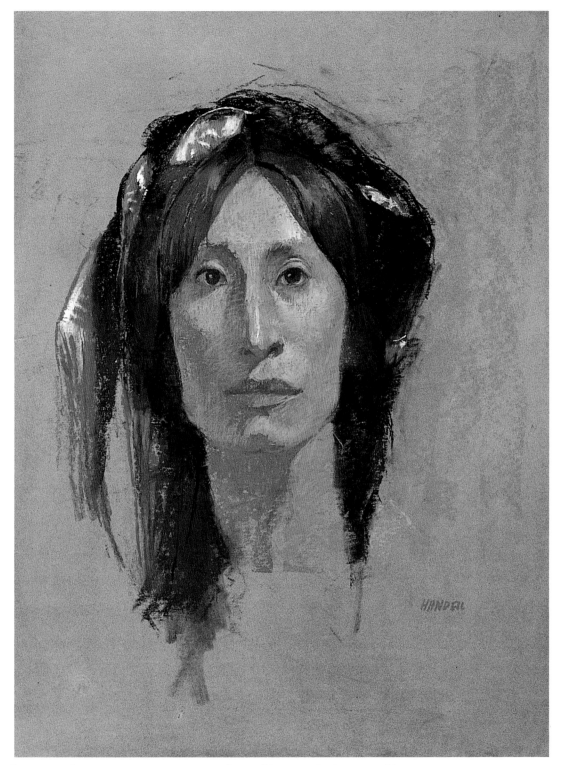

PORTRAIT OF CAROL, *pastel on sanded board, 15¾" x 21½" (40.0 x 54.6 cm). Courtesy of the Ventana Gallery, Santa Fe, New Mexico.*

Here I pan in on Carol, eliminating everything else and focusing on her portrait. This alone immediately creates a dynamic effect. A warm light illuminates the left side of Carol's face, establishing strong patterns of light and shade that cut across her features. Within these patterns, the features are placed as accurately as possible to give as good a likeness as possible. The lights of the portrait are kept very warm and rich in color. The shadows of course are darker, but all are kept comparatively neutral or cool in color. This close-up type of portraiture allows for the probing of the psychological aspect of the sitter, which adds even more interest to the dynamic effects of the close-up.

# Backgrounds in Composition

In many cases, the background of a painting works as a subordinating area, the tones and shapes of which need to be simplified or integrated into the composition to support the main compositional idea. The background is just what the word suggests—a less significant area than the foreground that harmonizes with the foreground yet does not compete with it.

Backgrounds can be kept as simple tones or masses. Or they can be complicated, made up of many patterns and shapes. Good portraiture, landscapes, and still life painting do not always need to have complicated backgrounds, and one often encounters situations in which the background shape or shapes can be represented by simplified masses or tones that recede as the foreground objects come forward. Usually,

TAOS COTTONWOOD, *oil on masonite panel, 18" x 20" (45.7 x 50.8 cm). Collection of Mr. and Mrs. Robert V. Hatcher, Jr.*

*Taos Cottonwood* is a very striking painting. The time is early spring and the sap is starting to rise in the trees. It's a week or so before delicate green buds will come out on the trees, giving them that light yellowish green tone that's so characteristic of spring. At this moment, the winter gray tones of the tree were gone and had been replaced by the surging inner energy of the tree, giving the branches a very reddish tone. I was so intrigued by this that I focused in on the trees, making them and the ground plane the center of interest. Also, since it had rained, there were some reflections, plus remaining white snow patches here and there amidst the suggestion of adobe buildings in the background. All made for a very rich foreground. To balance this, I simplified the background sky, using tones of blue gray colors varying in value, which contrast beautifully with the warm rich foreground colors.

the colors of the background tones are cooler as they recede behind the warmer colors of the foreground. The background tone may be the same throughout, or it can vary in value from light to middle or dark. However, where the background tone meets and touches the foreground area, decide if the line made is sharp, muted, or lost. This will tie up and "marry," mass together, or contrast the shape relationships created in the composition.

When the background is made up of many complicated shapes that represent objects in the background area, the proportional size relationships between the foreground and background objects need to be considered. In order to suggest the objects but keep them from competing with the foreground, an overall pattern or shape is arrived at and the background objects are painted with comparatively muted colors. Again, where each background object touches a foreground object, the lines created need to be studied—whether they are sharp, muted, or lost—in order to tie up the foreground-background relationship. Compositionally, the main focus is in keeping the background patterns well massed so that they do not jump out and come forward, disrupting the harmony and integration of the foreground-background relationships. Always keep the main focus where you intended—on the center of interest.

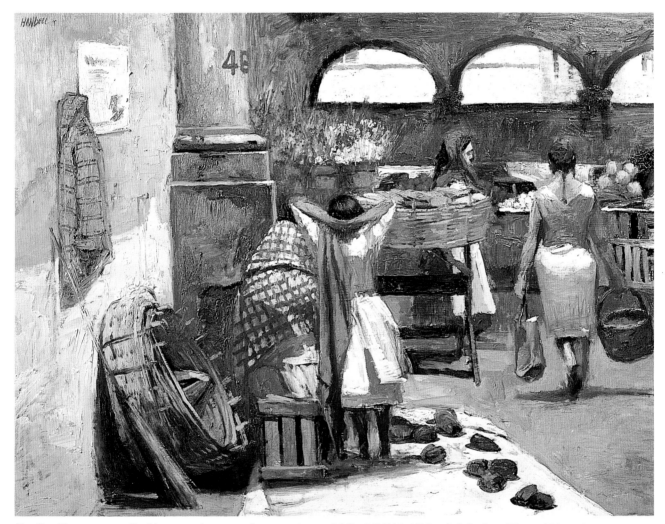

THE OLD MARKETPLACE IN SAN MIGUEL DE ALLENDE, *oil on masonite panel, 20" x 24" (50.8 x 60.9 cm). Collection of Bim and Diane Moncure.*

This interesting market interior combines an active foreground with a complicated background. The focus is on the young girl with her arms raised, folded behind her head. Her elderly grandmother, clothed in a rebozo and seated in front of her; the large straw bread basket leaning up against the wall; and the suggestion of produce on the white cloth on the floor complete the foreground center of interest. A woman in the foreground, her back to us, walks into the background. This device creates a pleasant way for the eye to follow her and move from foreground to background. The background is simplified, with basically shapes and patterns of color to suggest the activity of people moving among the stalls of produce. The entire painting is kept slightly on the cool side, with warm colors strategically used to suggest the sunlight seen through the arches of the pillars. This glimmer of sunlight adds space, variety, and interest to the background.

# Division of the Picture Plane

There are endless possibilities for the division of the picture plane, but the important point is that a realization of this and a consciousness of the various ways of making pictorial divisions will make an artist much more sensitive to the way this also happens in nature. Nearly all objects are understood through surface divisions made of lines or edges.

Here again, the elements of composition as discussed in Part II come into play. Shapes relate to one another and to the picture plane. Variety is achieved through horizontal, vertical, or diagonal divisions and movements, etc. The central design elements or the largest shapes may be placed in the center of the picture plane or to one side. Horizontals may be repeated by other horizontals or may be contrasted with verticals or diagonals that cut across whole or parts of areas. These divisions may be reinforced or contrasted by chains or rhythms of connecting or dis-connecting directions; repetition or contrasts of shapes and movements; or tonal massing, which adds to creating unity in the divided picture plane.

No matter what the basic composition is it is essential to remember that the shapes and movements of the subject relate to one another and to the picture plane, creating the divisions of the picture plane. These divisions are subtleties of the composition and are intrinsic to the painting's carrying power.

SUNDAY'S SNOW, *oil on masonite panel, 30" x 36" (76.2 x 91.4 cm). Collection of Marilyn and Ronald Racca.*

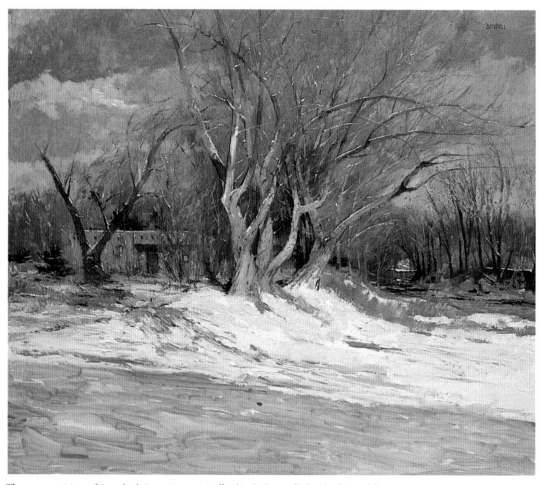

The composition of *Sunday's Snow* is practically divided equally by the line of the trees, the placement of the adobe to the left, and the background trees to the right. The top half of the composition is comparatively complicated and carries practically all the pictorial interest, whereas the bottom half is kept very simple, thereby leading the eye into the upper half of the painting. The bottom half is further cut in half by a strong horizontal line, this time the line of a cast shadow. The divisions of the bottom half of the composition add to the drama of the painting and allow the viewer's eye to go directly to the foreground trees, the center of interest. The beauty of the foreground trees hold the viewer's attention, their subtlety and detail drawing it away from the emphatic division of the picture plane. Although there are endless possibilities for dividing a picture plane, this example shows how effective the simple and direct way can be.

# Using Contrast

There are several different types of contrasts. Value contrasts, size contrasts, linear contrasts, color contrasts, etc. Using contrasts in a composition is important, for it gives variety to a painting and it separates the various areas of the composition, which allows for strong massing. Contrasts should be used judiciously, for too much contrast can negate the impact of it. There should be basically one dominant value contrast, one dominant color contrast, or one size contrast, which ideally should not be competed with. This keeps the viewer's attention where the artist wants it to be. Subordinate contrasting areas should not draw attention from the main interest.

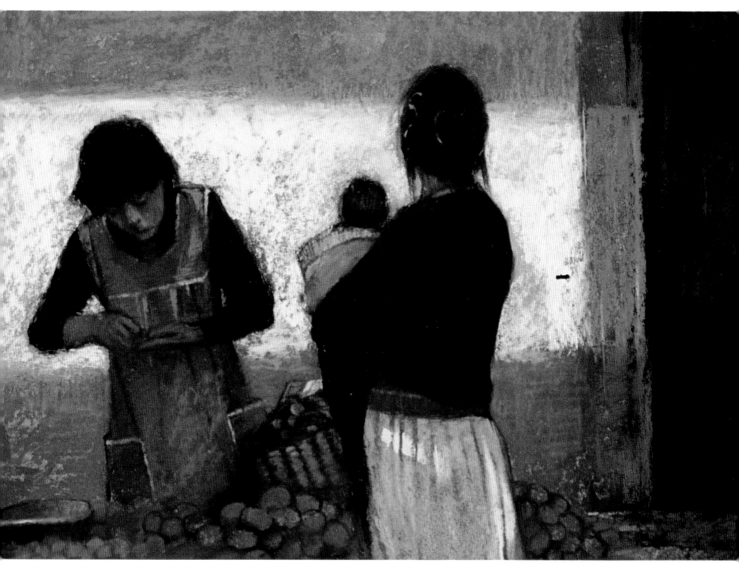

MOTHER IN PURPLE, *pastel on sanded board, 11" x 16" (27.9 x 40.6 cm). Collection of Audrey and Alan Schulman.*

Because of the sharp contrast resulting from the sunlit wall behind the foreground figures, I was able to develop them more as shapes, as vignettes or silhouettes. This type of contrast created strong carrying power and allowed for simplication and dramas. As I developed the shapes of the figures, I made sure that the amount of detail established did not weaken the carrying power I had obtained through the use of the strong contrast.

# Using Repetition

Using repetition as a tool in a composition allows good opportunities to obtain variety yet helps keep a harmony and a unique feeling of unity. It is a direct way to allow the eye to move slowly from one side of the composition to another. For although the elements are repeated, like a picket fence or a group of trees, they are not repetitive. They are not the same. They are similar yet at the same time full of variety and interest. There is an echoing of one shape or detail by another, one rhythmic movement by another. Within the repetition, lots of variety can be continuously found.

This close-up of a yellow adobe wall, which is mostly in shadow but has a touch of sunlight, provides an ideal backdrop for the delicate arrangement of young trees. How this group of trees was painted was important to this composition. I didn't want them to be overbearing. Therefore, I simplified them and made use of the repetition of the tree trunks to move the eye from the foreground into the painting. Although the eye travels throughout this composition, enjoying all the areas of it, when it views the painting the attention is unconsciously held by the subtle repetition in the trees.

THE WALL, *pastel on sanded board, 16" x 22" (40.6 x 55.8 cm). Collection of Civerolo, Hansen & Wolf, P. A., Albuquerque, New Mexico.*

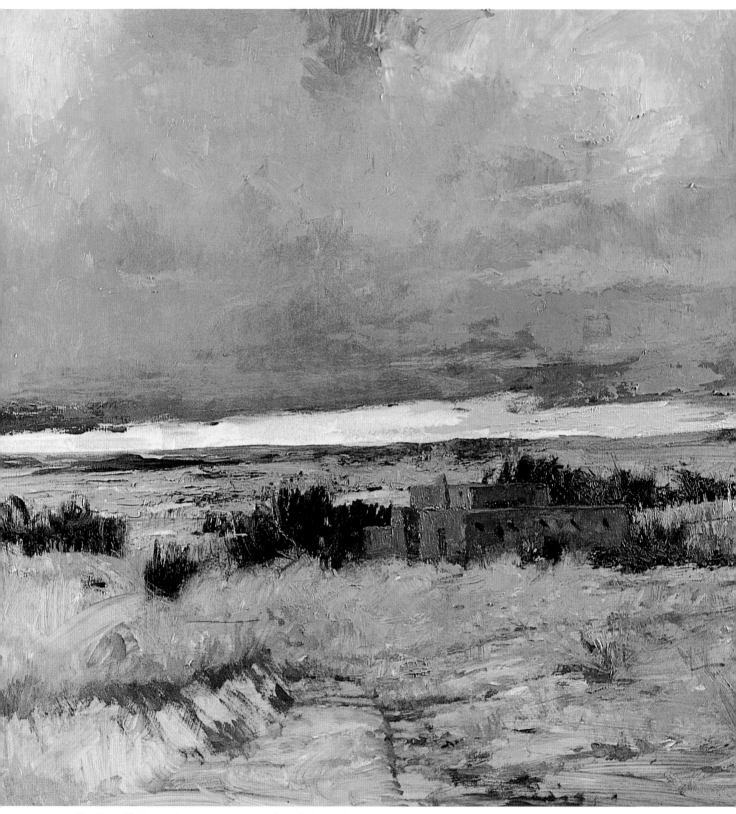

OLD SANTA FE TRAIL, *oil on masonite panel, 24" x 30" (60.9 x 76.2 cm). Collection of Mr. and Mrs. John Stahr.*

# Creating Depth

A feeling of depth in space is a natural part of the real world. Therefore, any realistic composition needs to have a sense of depth in order to achieve that desired effect of realism.

One way to create a sense of depth on a flat two-dimensional surface is to keep proper proportions and perspective in relation to the size of the objects in the foreground and the size of the objects distant in the background. Objects appear to decrease in size as they recede in space.

Another way to create depth is to overlap the planes of objects in the composition. But take care to see that the shapes remain interesting and that the reality has been well evoked.

Depth can also be created by eliminating details in the background and by having less value contrasts and more muted tones and softer edges. The background area will then recede. To add still more contrast to the background depth, keep the most interesting details, the strongest value contrasts, the sharpest edges, and the strongest colors all in the foreground.

There's nothing in the foreground of *Old Santa Fe Trail* to hinder the viewer's attention. Everything leads the eye into the painting to the group of suggested adobe buildings and surrounding dark piñon trees, which are all painted small and without details. This, plus their placement, creates an immediate feeling of depth to the painting. The sky adds to this dramatic sense of depth because it is painted in such a way that the viewer's eye is led to the thin brilliant yellow band of light behind the adobe. This also pulls the eye into the painting and keeps it there. All combined, these elements create a rapid perspective, a rapid movement of the eye into the painting, thereby creating the sense of depth here.

# Using Reflections

Using the reflections in a mirror can add a lot of interest, depth, and variety to a composition. Usually reflections are not an obvious part of the first impression but appear rather after the impact of the first impression is absorbed and we begin to look into the areas and details of the painting. Suddenly, we see an entire new world, not noticed at first, in a mirror or in a reflection in a window glass. This mirrored world is usually of a secondary delight. It can add tremendous depth and interest to the dynamics of a composition.

Other examples of reflections that can add to compositions are the reflections we find in puddles of water or on wet streets. Use of these reflections can change the format of a composition. For instance, they add to the composition vertically, even though the basic composition may be a horizontal one.

Reflections add an extra dimension to a painting. Usually, one immediately has an overall impression of a painting and then, afterward, slowly enjoys the details. There's an added dimension to a painting with a mirror or some sort of a reflection—a surprise factor. *The Dresser* is a good example of this because the objects reflected in the mirror have more distance to them than the still-life objects right in front of it. The reflected objects are simplified and painted with less texture and detail. Basically, they are suggested by their planes and their light and shadow masses. This adds to the sense of remoteness. Surrounding objects are more complete, more finished, with more texture, which shows their closeness to the viewer and his focus of attention.

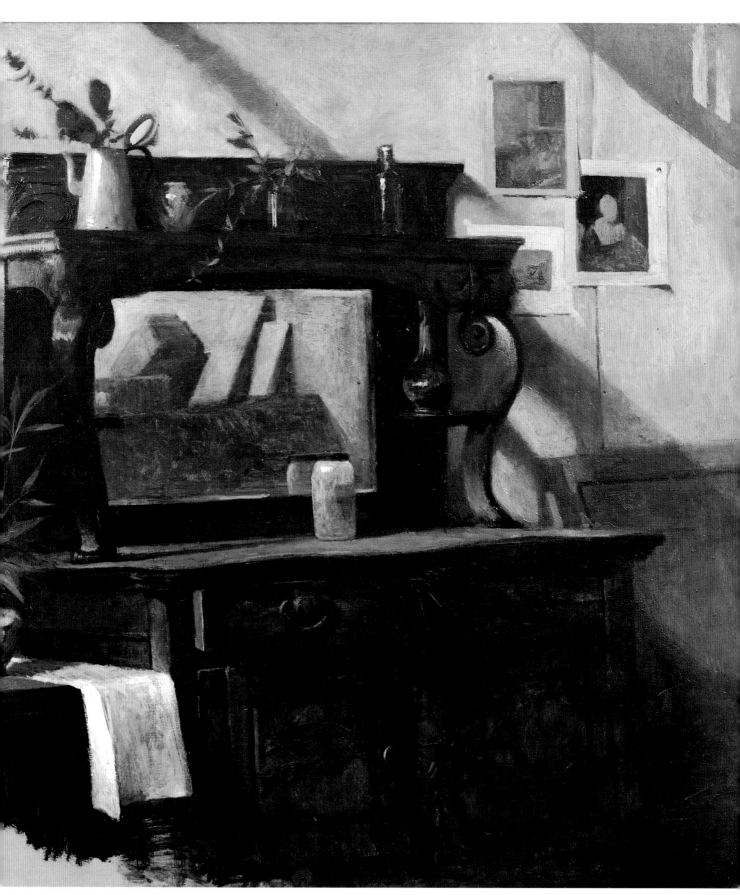

THE DRESSER, *oil on masonite panel, 30" x 36" (76.2 x 91.4 cm). Collection of Max and Lee Salomon.*

# Different Compositions of the Same Subject

The possible compositional variations that can arise from working time and again from a small group of favorite subjects can become endless. Add to this the different compositional views of being close-up or farther away from the subject, the different light conditions, the different seasons, the different times, the kinds of days, the effects of changing weather conditions.

As I keep returning to the same subject, seeing it in ever new ways, I also become more sensitive, intimate with, and familiar with the subject. That subtle hard-to-define element that comes only with familiarity and time spent with a beloved subject also becomes part of my compositions.

In this section, I will compare three different compositions of the same subject, composed from a black-and-white photograph of a rural scene in Galisteo, New Mexico. While visiting there one day, this scene caught my eye. I took a series of photos, and the one reproduced here was the one I valued the most and basically worked from.

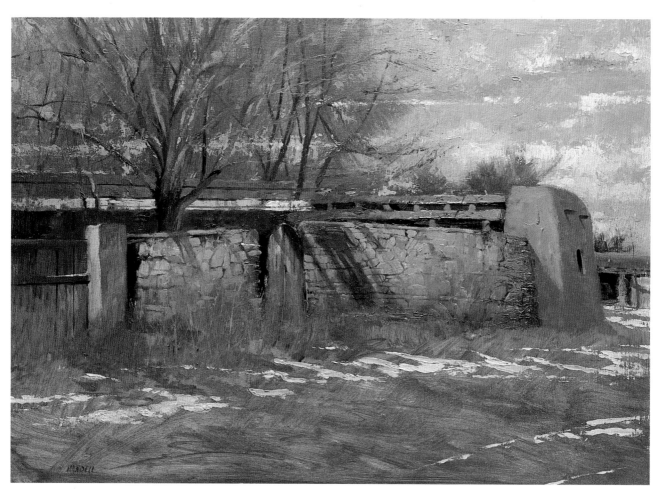

SHADOW ON THE WALL, *oil on masonite panel, 20" x 24" (50.8 x 60.9 cm). Collection of William F. Maguire.*

In composing *Shadow on the Wall,* I tried to be both literal and creative. The entire subject was bathed in full sunlight with the only contrast on the wall being the sharp, angular cast shadows. To emphasize this, I eliminated part of the wooden fence to the left of the wall and added more distance to the right of it. I kept the lighting condition pretty much the way it was that pleasant sunny day. The stone wall was basically a tone of light Naples yellow. It contrasted beautifully with the soft lacy winter branches behind it, which were gray and mauve in tone and color. Altogether, this became a special composition of a favorite subject.

THE YELLOW WALL, *oil on masonite panel, 20¹/₄" x 23¹/₂" (51.4 x 59.6 cm). Collection of Stephen and Karen Plax.*

In this painting I wanted to emphasize the intensity and excitement of the yellowish colors of the stone wall when it was hit by sunlight. To achieve this effect, I painted in a dramatic sky, making it as dark and as rich in tones of gray and purple as I could. For the sky I kept the paint quality very buttery and opaque. Then, in the bottom areas of the painting, I contrasted this by keeping the colors warm, rich, and transparent. I glazed in a warm, transparent cast shadow that allows the details of the underpainting to be seen. This glaze adds special color effects and textural qualities to the painting. I then proceeded to paint the details and intense colors of the stone

wall, which was in striking sunlight. I put in as much detail as I could without weakening the dramatic light condition. There was lots of painting done on the trees to capture the quality of the winter laciness of the branches. The reddish brown colors of the lacy areas of the branches were very close in value to the dark cool purple colors of the sky. Therefore, no matter how much detail I put there, no matter how thick the buildup of paint I applied, it all blended together visually because of the close values of the two areas. Notice how the dramatic light condition affected the choices made in composing this same section of stone wall.

SUNLIGHT ON THE WALL, *pastel on sanded board, 18" x 24" (45.7 x 60.9 cm). Collection of Bruce and Vida Fox.*

I was fascinated by the details and the rich, varied yellow colors I found in the rock wall. I decided to tone the surface for this pastel in a transparent rich purple color, retaining as much transparent color throughout as possible. Much of this color can still be seen in the upper half of the composition. I then focused in on the wall and the white gate, pulling the eye to this area by means of details. The details are lost as the eye leaves this area, adding atmosphere, space, and a dreamlike quality to the composition. The original underpainting, composed of transparent turpentine color washes of rich purples, is the complement of yellow. I allowed these colors to show throughout the composition, letting them become an important part of it. Again, just a shift in emphasis, a shift in lighting or color theme, creates a beautiful but different composition of the same subject.

# Composing from Beginning to End

The idea of composing from beginning to end takes in many of the compositional approaches we have worked with in previous sections. Only now they are integrated into the artist's awareness, they are second nature and are used intuitively as the painting develops.

The composition is something that grows and develops the entire time the painting is on the easel. Usually, the composition is begun by trying to establish the first impression onto the canvas. But the options are always left open for redesigning from beginning to end with the possibility of lots of modification. Usually, these early decisions are based upon the way the compositional elements relate to the first impression. Being open and flexible to adjustments can make all the difference between a special painting or just a good one. Stay open to experimenting to see what works and what doesn't.

As you compose from beginning to end, continue to study the subject well—its rhythms, proportions, and masses. Always keep in mind the harmony of the shapes and the light and dark value relationships. These relationships are what add to the solidity and carrying power of the composition. Always continue to check and recheck them throughout the working of the painting until they are as simplified as possible and are integrated with the realism of the painting to the greatest degree possible. Always continue to integrate all of the parts as you proceed, keeping in mind the whole design of the composition, not getting caught up in the unimportant details.

At some point, you will reach a place where you have everything that you want or you are just not sure what to do next. You'll have to ask, "Does anything more need to be harmonized or simplified?" "Do the composition and the realism hold together as a cohesive whole?" "Is the composition fully resolved?"

Intuitively you will sense that you are at a point where you cannot really continue with enthusiasm. At this point stop. Do not arbitrarily continue working because you feel you have to. Give the painting the test of time. Turn it around, facing the wall. Don't look at it and try to forget it if you can. After a few days time or after a week or so, turn the painting around and look at it with a fresh eye. You may see that something else is needed to be put in or taken out. Then you'll be able to work again with fresh creativity.

The more you allow time to become a part of your creative process, the more integrated your vision and sense of intuition will become. And the more your paintings will radiate that intangible sense of life that separates special paintings from just good ones.

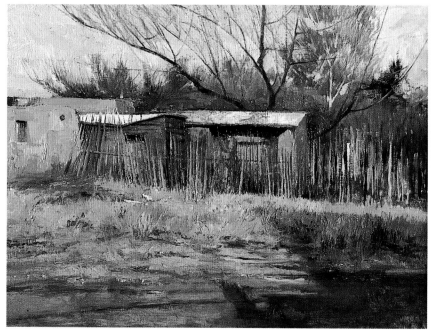

EARLY SPRING, NEW MEXICO, *oil on masonite board, 20" x 24" (50.8 x 60.9 cm). Collection of the artist.*

In *Early Spring, New Mexico,* I didn't just zero in on one area and build the composition out of this, which is one way I often go about composing. Instead, owing to the complicated arrangement of the buildings and coyote fence all bathed in bright afternoon light, I established the entire composition in the initial layout. I kept all the colors of the painting high in key, including the cool cast shadow on the lower right. As the coyote fence and the buildings took shape, they were interwoven with the surrounding trees. The contrasting patterns of the light blue sky and all the warm earth colors of the buildings and foreground make up strong color patterns in the painting. As I worked from beginning to end, I continued to intensify these colors and the shapes and masses they created in order to keep them harmonized and to continue to strengthen the carrying power of the composition.

LATE AFTERNOON LIGHT, *pastel on sanded board, 15-¾" x 21-¾" (40.0 x 55.2 cm). Private collection.*

Laying out the entire painting before establishing any detail is always a good idea, especially when the light will be disappearing rapidly, as it did here. With only another ten minutes to work the light, I quickly laid out the entire composition for *Late Afternoon Light*. At a certain point, I focused on the details, the specifics, taking a lot of care for their accuracy. As areas of the painting were adjusted to accommodate more accurate placement, the composition was modified here and there in order to compensate for these details. For instance, in order to bring out the details of the coyote fence, with its variations in color and size of poles, I needed to lower the whole line of the roof of the shed directly behind it so it wouldn't end up appearing too wide. Subsequently, the tree directly behind the shed had to be adjusted in order to maintain correct proportional relationships. Working in this way is like breathing in and out; it calls for continued flexibility and sensitivity in composing from the beginning to the end of a painting.

THE HIGH ROAD TO TAOS, 1987, *oil on masonite panel, 24" x 30" (60.9 x 76.2 cm). Collection of Dr. and Mrs. Hugh Parchman, Jr.*

Composing from beginning to end means being involved with the composition, without interest in detail breaking up that clarity. It can also mean substantial compositional changes and modification if needed, even when well into a painting. This was the case with *High Road to Taos, 1987.*

I was composing from a drawing done on location. There was a very dominant, interesting tree located in the middle of it. I was focusing on the tree and thought I had a good composition going, but whenever I worked on the tree, it didn't feel quite right. I gave the painting the test of time and turned it to the wall.

After a few weeks, I turned it around and, with a fresh eye, realized immediately that the tree had to be taken out and that the foreground needed to be handled more broadly to compensate for it. As soon as I removed the tree, the composition changed completely. I then tied up the foreground background areas, relating the tones of the purple colors in the foreground to the tones of the purples in the sky. These color similarities pull the eye from the top to the bottom and back again.

Working in this way is a reminder that although my first compositional decision was based upon my first impression of the tree as center of interest, being open and flexible to the adjustments resulted in a special, dynamic painting.

# INDEX

Abstraction, 20
*Adobe Shadows,* 84–85
Aerial perspective, 92–93
*After the Rain,* 8–9
*Afternoon Light in Abiquiu,* 82
*Afternoon Veranda,* 118
*Along the Rio Grande,* 26–27
Angles, opposed and unopposed, 54–56
Appearance of reality, 20
Artistic license, 102–3
*Asleep,* 70
Asymmetry, 57–61
Atmosphere, 82–87

Backgrounds, 124–25, 131
Backlighting, 66
Balance in composition, 17, 37
*Banana Vendor, The,* 52–53
Beginning to end, composing from, 138–41
*Blue Rebozo, The,* 74–75
*Blue Window,* 99
Bridgeman, George, 9

Cast shadows, 66, 67
*Catskill Stream, The,* 88
Center of interest, 100–101, 114–15
Circular movements, 48–50
Clarity of shapes, 26
Close-up, dynamic effect of, 120–23
Color in composition, 64, 70–75, 125
Complementary color, 70–71
Composing in color, 72
Composition. *See* Elements of composition; Seeing the composition; Technical influences on composition
*Contemplation—1988,* 3
Contours, 94
Contrast, using, 127
*Conversation at the Market,* 111
Cool color, 72, 75
*Corner of My Studio,* 31
*Corrales,* 32, 112–13
*Cotton Wood Grove,* 24–25
*Cottonwoods,* 81
*Coyote Fence, Santa Fe, The,* 72–73
*Coyote Fence, The,* 94–95
Creative approaches, 97–141
    artistic license, 102–3
    backgrounds, 124–25
    center of interest, 100–101, 114–15
    composing from beginning to end, 138–41
    composing from drawings, 106–9

composing from life, 104–5
composing from photographs, 110–13
contrast, using, 127
depth, creating, 130–31
different compositions of same subject, 134–37
division of picture plane, 126
dynamic effect of close-up, 120–23
first impression, 98–99, 138
placement, 114–15
reflections, using, 132–33
repetition, using, 128–29
simplifying shapes and unifying compositions, 116–19
Curved movement, 48–50

*Delgado Adobe,* 68
*Delivery, The,* 62–63
Depth, creating, 48, 130–31
Detail, 78–79
Diagonal movement, 44–47
Division of picture plane, 126
Drawings, composing from, 106–9
*Dresser, The,* 132
Dry painting, 80

*Early Spring, New Mexico,* 138
Edges, lost and found, 26, 76–77
*Elderly One, The,* 43
Elements of composition, 25–61
*Elements of Dynamic Symmetry, The* (Hambidge), 9
Empty negative space, 37–38
Environment, perception and familiar, 14
Eye level, 92

*February, Woodstock, New York,* 102
Feeling, 22, 114
Finishing, selective, 78–79
First impression, 98–99, 138
Flat light, 66
Found edges, 26, 76–77
*Friday Market,* 28–29
*Friday Market at Patzcuaro,* 54–55
*Fuji Mums,* 13

*Gas Pipe, The,* 37
*Gourds, The,* 65
*Grandma's Helper,* 78
*Guest House,* 18–19

Half light, 66
Hambidge, Jay, 9
*Hanging Pots, The,* 47

Harmony in painting, 17
*High Road to Taos, The,* 50, 140–41
Horizontal movement, 39–41
Hue, 71

*Icing Over,* 71
Impression, first, 98–99, 138
Individual style, 20
Intensity, color, 71
Interest, center of, 100–101, 114–15
Intuition, 13, 14, 22, 98

*Ladies in Blue, The,* 86–87
*Last Light, Santa Fe,* 116
*Late Afternoon Light,* 139
Life, composing from, 104–5
Light, 66–69, 123
*Light, The,* 69
Linear curve, 48
Linear perspective, 92–93
Lines, 94–95
Lost and found edges, 26, 76–77
Luminosity, 82–87

*Market at San Miguel de Allende, The,* 56
*Market Rest,* 66
*Market Steps, Patzcuaro,* 115
Mason, Frank, 9
Masses and massing, 64–65, 117
*Moments of Choice,* 119
*Monday,* 108–9
*Mother and Child,* 58–59
*Mother in Purple,* 127
*Mountain Laurel, Detail,* 17
*Mountain Stream, Woodstock, New York,* 103
Movement
    seeing, 13
    types of, 39–61
*Mums #1,* 49
*Mums #2, The,* 59

*Nambe Farm,* 60–61
Negative space, 34–36
    empty, 37–38
*New Mexico Winter,* 87
*Next Day, The,* 92

Oil painting, texture in, 80
*Old Adobe, Santa Fe, The,* 79
*Old Marketplace in San Miguel de Allende, The,* 125
*Old Santa Fe Trail,* 130–31
*Old Zia Road, Santa Fe,* 83
Opposed angles, 54–56

*Orange Roof, Santa Fe, The,* 36
*Oriental Rug, The,* 89

Pastel painting, texture in, 80
Patterns, 30–31, 44
*Pecos Wilderness,* 90–91
Perception, 14
Personal vision, 14, 20
Perspective, 44, 48, 92–93, 131
Photographs, composing from, 110–13
Picture plane, 32, 126
Placement, 114–15
Planes, 32–33, 92, 126, 131
*Portal Shadows, Santa Fe,* 120–21
*Portrait of Barbara,* 57
*Portrait of Carol,* 123
*Portrait of Ed Sachs,* 33
*Portrait of Jerry Schiffer,* 48
*Portrait of My Mom,* 46–47
*Portrait of Neil,* 38
*Portrait of Peter Martin,* 84
Portrait painting, close-up, 120, 123
Positive space, 34–36
Pre-toned ground, 72
Primary colors, 70, 72
Priscilla, Louis, 9
*Profile of Susan,* 76
Proportional relationships, 90–91

Realism, 20, 30
Reality, artistic vision and, 16
*Rebozo Lady, The,* 100–101
*Red Awning, Mexico, The,* 117
*Red Berries, The,* 40
Reflections, using, 132–33
Repetition, using, 128–29
Rhythms, 13, 49, 50
Rim lighting, 66
*Rocks at Kaaterskill, The,* 51

Same subject, different compositions
    of, 134–37
*Santa Fe, Snow,* 106–7
*Santa Fe Hills,* 10–11
*Seated Female Nude,* 80

*Seated Male Nude,* 114
Secondary colors, 70
*Sedona,* 34–35
Seeing the composition, 11–23, 26
Selective finishing, art of, 78–79
Shade, 66–69, 123
*Shadow on the Wall,* 134
*Shadows, Santa Fe,* 96–97
Shapes, 26–29, 51, 88, 92
    positive and negative space, 34–36
    simplifying, 75, 116–19
Sharp edges, 76
Simplicity, 17, 75, 116–19
Soft edges, 76
Space
    empty negative, 37–38
    lines dividing, 94–95
    negative and positive, 34–36
*Stream, The,* 30
*Strolling, San Miguel de Allende,* 20–21
Subjective lines, 94–95
*Summer's Moment, A,* 14–15
*Sunday's Snow,* 126
*Sunlight on the Wall,* 136–37
*Sun-Washed Portal,* 67
Surface realism, 20
Surface texture, 80–81
*Swirling Branches,* 104
Symmetry, 57–61

*Taos Cottonwood,* 124
*Taos Magenta,* 105
*Taos Winter,* 98
Technical influences on composition,
    61–95
    color, 70–75
    detail and art of selective finishing,
        78–79
    light and shade, 66–69, 123
    linear and aerial perspectives, 92–93
    lines and subjective lines, 94–95
    lost and found edges, 26, 76–77
    luminosity, weight, and atmosphere,
        82–87
    proportional relationships, 90–91

tension, 88–89
texture, 80–81
values and masses, 64–65
Tension, 88–89
Tertiary colors, 71
*Tesuque Light,* 5
Texture, 80–81
Third dimension, illusion of, 116
Tonal attitude toward color, 72, 125
*Trees in Winter,* 77
*Trees in Winter, The,* 42
Triangular movement, 51–53

Unconscious, visual perception and, 14
Unifying compositions, 116–19
Unopposed angles, 54–56
*Upper Canyon Road,* 12

*Vacuum Cleaner, The,* 39
Values in composition, 64–65
    color, 64, 71, 75
Vertical movement, 42–43
*View, Santa Fe, The,* 64
Vision
    artist's, 12
    personal, 14, 20
    reality and, 16
Visual paintings, 13

*Wall, The,* 128–29
Warm color, 72, 75
Watercolor medium, texture in, 80
Weight in painting, 82–87
Wet painting, 80
*White Fur Coat, The,* 52
White ground, 72
*White Pine, The,* 16
*Winter Mauve,* 22–23
*Woodstock Stream,* 40–41, 93

*Yellow Wall, The,* 135

Zen of seeing, 13
*Zig-Zag,* 44–45

Edited by Grace McVeigh
Designed by Jay Anning
Graphic production by Ellen Greene

**Photo Credits**
Albert Handell Studios, Inc.
Anthony Seurer with M. Tincher Photography, Santa Fe, New Mexico
Susan Contreras Photography, Santa Fe, New Mexico
Tom Reynolds Photo Studio, Kingston, New York